# LANKA

First Edition

ISBN 1 873938 11 X

British Library Cataloguing-in-Publication Data.
A catalogue record for this book is available from the British Library.

Design by Cooper-Wilson and J C Graphic
Production by Anna Watson

Typeset by Brains Typography, Reading
Photographic reproduction by Hermes Plates, Reading

Printed in Italy by Grafiche Milani

Published by Garnet Publishing Ltd.
8 Southern Court, South Street,
Reading RG1 4QS UK.

My special thanks for the assistance and support given in the exhibitions and publication of the photographs to:

Air Lanka
Archaeological Society of Sri Lanka
Art Gallery, Colombo
Barefoot
The British Council
Ceylon Tourist Board
Cultural Survival Trust
David Gladstone
Dr P Saravanamuttu
Dr Rama Coomaraswamy
General Sepala Attygalle, Sri Lankan High Commissioner
Ministry of Culture, Sri lanka
Ministry of National Security, Sri Lanka
Mr KD Somadasa, The British Library
Mrs Jean Chamberlain
Rt Hon Gamini Fonseka
Taj Samudra Hotel
Venerable Galaboda Gnanissara Thera

Thanks are due to the following for permission to reproduce the illustrations and quotes as follows:

'The Hamsa', *Medieval Sinhalese Art* by A K Coomaraswamy;
*Art, Man and Manufacture from Sources of Wisdom* by A K Coomaraswamy;
'The Makara', *Medieval Sinhalese Art* by A K Coomaraswamy;
'The Yama Raksaya', *Medieval Sinhalese Art* by A K Coomaraswamy;
'The War of Temptation', *Design Elements from Sri Lankan Temple Drawings* by L T P Manjusri;
'A Mudalyar Flanked by Two Europeans and Queen Victoria', *Design Elements from Sri Lankan Temple Drawings* by L T P Manjusri;
'Hands' by M Willet.

# LANKA

### 1 9 8 6 – 1 9 9 2

S T E P H E N   C H A M P I O N

GARNET
PUBLISHING
LIMITED

# INTRODUCTION

There was little conscious reasoning behind my shift from the United States of America, where I had been living, back to London, and then on to Sri Lanka. In retrospect it seemed symbolic of my increasing discontent with the 'American experience' and the Thatcher years. I had thought to travel extensively throughout Asia and to immerse myself in the antithesis of all things Western. On arrival in Sri Lanka it became apparent that there was little reason to travel any further. Almost immediately I felt at home, my closeness gradually gaining depth. I found myself in a world of great generosity and virtue; of kindness and acceptance.

I began to make photographs and although I was advised against travelling to restricted areas, I found myself in one such place. I discovered there the heart of Sri Lanka, bloody and divided.

During each subsequent visit I returned with necessary permits and recommendations, and the confidence of the appropriate authorities. I was in a unique situation: I could travel more freely than a Sri Lankan, I could live in all communities without fear of persecution, and I was prepared to spend the time necessary to achieve an objective and intricate perspective. This was not without incident or risk, though I was privileged with a freedom to study and photograph in depth; a right denied to most Sri Lankans.

This book follows a loose chronology. From early exoticised clichés and romantic misconceptions of the 'paradise' isle, to moments of absolute terror and brutal barbarism, to mesmerising tranquillity and balance.

This is my chronicle of a people who have treated me well and taught me much; of love, passion, and nature, of a gentle and beautiful possibility poisoned by wars.

There is no such thing as a war crime. War is the crime.

*Stephen Champion, 1992*

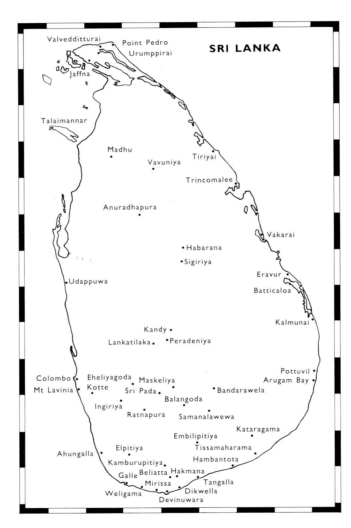

SRI LANKA

Valvedditturai
Point Pedro
Urumppirai
Jaffna
Talaimannar
Madhu
Vavuniya
Tiriyai
Trincomalee
Anuradhapura
Vakarai
Habarana
Sigiriya
Eravur
Batticaloa
Udappuwa
Kandy
Peradeniya
Lankatilaka
Kalmunai
Colombo
Eheliyagoda
Maskeliya
Pottuvil
Mt Lavinia
Kotte
Sri Pada
Arugam Bay
Bandarawela
Balangoda
Ingiriya
Ratnapura
Samanalawewa
Kataragama
Embilipitiya
Ahungalla
Elpitiya
Tissamaharama
Kamburupitiya
Hambantota
Galle
Beliatta
Hakmana
Mirissa
Tangalla
Weligama
Dikwella
Devinuwara

# SRI LANKA

The island of Sri Lanka lies just south of the southern tip of India. It is 272 miles long and around 150 miles wide at its widest. The largely rural population totals approximately 17 million, of which 74% are Sinhalese and Buddhist. They live mainly in the southern, central and western provinces. Tamils represent 18% of the population and mostly live in the north and east of the country. They speak Tamil and are predominantly Hindu. The hill country Tamils were brought over from India by the British, and only gained full citizenship in 1985. Muslims, totalling around 7% of the population, are to be found in all areas and generally speak Tamil, and often Sinhala.

Sri Lanka's climate is equatorial with two monsoons and as a result the land is mainly very fertile. Villages are surrounded by cultivated terraces providing fruits, vegetables, paddy, spices and local medicines. The sea and rivers abound with fish. The staple food, rice, is grown only for domestic consumption due to a lack of sustainable irrigation, a sad irony as centuries ago vast areas were cultivated with water from ingenious tanks. Although most have fallen into disrepair, some remain; a tribute to the ancient master builders.

Today the mainstays of the economy are tea, rubber and coconut, continuing the plantation bias of the colonial era. Tourism, garment manufacture, gem mining and remittances from migrant Sri Lankan workers in the Middle East are the other major foreign exchange earners.

The Portuguese landed in Sri Lanka in 1505 and, having realised the island's wealth, established relations with the kingdom of Kotte by 1518. Through political manipulation the Portuguese gained control of all the country except the central kingdom of Kandy. Portuguese rule was repressive and often brutal, and was marked by intense activity from Roman Catholic missionaries. A legacy of this is the community of over a million Christians on the island today.

At the beginning of the 17th century the Kandyan kings of the central highlands solicited Dutch help to drive out the Portuguese. After a series of battles and truces the Dutch had control of the coastal areas by the 1660s, but failed in their attempts to take the Kandyan kingdom. The Dutch encouraged trade, and imposed their own judiciary alongside customary law.

In 1796 the British took over from the Dutch and in 1802 Ceylon, as it became known, was incorporated as a British Crown Colony. By 1818 the British had violently subjugated the Kandyan provinces, and thus controlled the entire island. The impact of British policy on the island's social and economic structures was dramatic. They introduced agricultural reforms and English became the language of government and education. In the 1870s the blighted coffee crop was replanted with tea and plantations of rubber and coconut were encouraged. The Sinhalese refused to work on estates that were neither theirs, nor established for the benefit of their community. The British ferried large numbers of Tamil workers across from India, and politically favoured non-Sinhalese groups in a policy of 'divide and rule'.

After the Second World War the 'Winds of Change' sweeping through the world brought an end to the colonial era and the British pulled out of Ceylon, granting it independence in 1948. Power passed to an Anglicised multi-ethnic elite with a Westminster system of parliamentary democracy led by the United National Party (UNP) under DS Senanayake. By the early 1950s, despite a commitment to subsidise imports, escalations in the world price of rice led to increases in the domestic price, resulting in riots, a state of emergency, and the resignation of Dudley Senanayake, who had succeeded to the premiership on his father's death. Consequently, Dudley Senanayake's uncle Sir John Kotelawala became Prime Minister, earning the UNP the nickname of the Uncle Nephew Party. In the elections of 1956, SWRD Bandaranaike and his Mahajana Eksath Peramuna coalition swept to power in a landslide victory. Sinhala became the official language and extensive state support was given to the Buddhist religion and Sinhalese culture. The government experimented with socialism and extended state control over economic development, though this created as many problems as it solved. The language

policy was bitterly opposed by Tamils, who came to favour devolution of power and were drawn to support SJV Chelvanayagam's Federal Party.

SWRD Bandaranaike was assassinated in 1959 and his widow, Sirimavo, became the new leader of the Sri Lankan Freedom Party (SLFP). She formed a government the next year, and intensified its nationalist policies. Unemployment, rising prices and a shortage of basic consumer goods contributed to the UNP's return to power at the elections of 1965, along with their plans for private enterprise and economic growth. But victory was short-lived and in 1970 an SLFP coalition led by Mrs Bandaranaike was elected back to power in a landslide victory.

In the south the disaffection of the young, educated unemployed continued, and in 1971 the leftist Sinhalese People's Liberation Front or Janata Vimukthi Peramuna (JVP) led an insurrection against the government which was ruthlessly and bloodily crushed with international assistance. In 1972 Ceylon was officially renamed Sri Lanka, and Buddhism was declared the state religion. But the government coalition soon fell apart, and the growing unpopularity of the socialist experiment was reflected in a wave of strikes and unrest.

In the north too, disillusion with the established political order was reflected in growing militancy amongst the young. This was compounded by Mrs Bandaranaike's nationalist policies, which increased Tamil insecurity and deepened the Sinhalese-Tamil divide. By the general election of 1977 the Tamil parties had united on a secessionist platform to form the Tamil United Liberation Front (TULF), and an armed militant movement had also been formed – the Liberation Tigers of Tamil Eelam.

The election took place amid wide-spread violence, but the UNP, under the leadership of JR Jayawardene, won a sweeping victory and the TULF became the main opposition party in parliament, where it continued to press for autonomy. As well as introducing free-market policies, opening the economy to foreign investment and setting up a free-trade zone, the UNP brought in a new constitution changing the system of government to an executive presidency.

Then, through the unprecedented use of a referendum, the government prolonged its stay in office until 1989. The TULF MPs resigned their seats in protest.

By 1983 Sinhala-Tamil relations had deteriorated to the point of full-scale civil war. Armed resistance increased in the north and, empowered by a stringent Prevention of Terrorism Act, the Sri Lankan army was deployed against the guerrillas. The situation reached a grim climax when an ambush of Sinhalese soldiers by the Tamil Tigers unleashed a savage frenzy of anti-Tamil communal violence throughout the country. The carnage and devastation of property made refugees of thousands of Tamils, and many fled to India. The government banned three left-wing parties, including the JVP, and passed an amendment to the constitution, denying civil rights to those who advocated secession.

For the next four years, armed conflict raged in the north and east between the Sri Lankan army and the separatist Tamil guerilla groups, led by Vellupillai Prabakharan, who gradually displaced the more moderate TULF as the standard bearers of the Tamil cause. Because of the sympathies of its southern state of Tamil Nadu, and its strategic interests as the pre-eminent regional power, India was drawn into support of the Tamils. In 1987 the violence extended to Colombo when a bomb exploded in a bus station killing over 100 people. The government responded by sending the army to take the Tamil stronghold of Jaffna.

India intervened by using planes to drop supplies to the Tamils, and subsequently an accord was signed between Rajiv Gandhi and the Sri Lankan President Junius Jayawardene. This accord envisaged, among other things, an end to hostilities; the surrender of weapons by Tamil militants and an amnesty for them; amalgamation of the northern and eastern provinces; repatriation of Tamil refugees who had fled to India; no use of Indian territory for military or propaganda purposes by the Tamils; and the provision that Tamil and English should have equal status with Sinhala as official languages.

India agreed to send a peace-keeping force, and at first negotiations with the Tamil Tigers and other groups made progress and some weapons were surrendered. But by October the talks had broken

down and the Tigers resumed their attacks. Civilian casualties were high. This time the situation was different. The Tamil Tigers found themselves facing the Indian Army which, after fierce battles and heavy losses on both sides, forced them out of Jaffna and back to their jungle strongholds. India sent in more weapons and troops until there were 100,000 Indian soldiers on Sri Lankan soil. They supported a Tamil group opposed to the Tigers, the Eelam People's Revolutionary Liberation Front (EPRLF).

The accord was also threatened by the re-emergence of the JVP in the South, which began its own campaign of violence. Despite JVP threats, President Jayawardene authorised the merger of the northern and eastern provinces in September 1988, and elections to the new north-eastern council saw most of the seats go to moderate Tamil groups and the Sri Lanka Muslim Congress. In December the constitution was amended and Tamil became one of Sri Lanka's two official languages.

Presidential elections in January 1989 saw Jayawardene replaced by Ranashinge Premadasa – the first non-ruling class politician ever to be elected head of government. The following month the UNP won a 25 seat majority at a general election marred by terrible scenes of violence. The new President and government faced strikes and protests organised by the JVP over the worsening economic climate and the continued presence of Indian troops in Sri Lanka. The response was to speed up India's withdrawal by initiating a pact with the Tamil Tigers, thus releasing government troops to work in the south against the JVP. Tens of thousands of mostly young men were hunted down, including the JVP leader Rohana Wijeveera. Violence in the south then subsided. A whole generation had been silenced.

The focus of violence again shifted to the north. When the last Indian troops pulled out, in March 1990, the EPRLF fled to India, fearing reprisals from the Tamil Tigers. After a few months of relative calm, the pact between the government and the Tigers broke down. The Tigers returned to battle positions, the government army braced itself for all-out war, and the conflict raged as before.

A popular and powerful voice of reconciliation and fairness, Major General Denzil Kobbekaduwa, was killed in an explosion in August 1992. Ironically the killing took place within army-secured territory, yet the Tigers were keen to claim responsibility. But as always, it was civilian casualties which were highest, and hundreds of thousands are housed in vast refugee camps. Villages have been destroyed, large areas booby-trapped or mined, and thousands killed.

President Premadasa has done much to steer the economy towards development by encouraging foreign investment and private enterprise. Campaigns to alleviate poverty and corruption have been launched, though the years of violence have left their mark and aid agencies still battle in the debris of war. Colombo, with its fast-expanding middle class, and the newly rich rubbing shoulders with the old power elite, is increasingly alienated from the surrounding country.

In the villages, of which the politicians so often speak, but seem to know so little, there are those whose course is steady, whose education is more than 2,000 years old, and on whose soil Sri Lanka has been built. Development represents the opportunity to assist the community or destroy it. With foreign investment and privatisation receiving firm encouragement, the agenda through the 1990s is set. Development is not achieved by the industrialisation of a nation, but by a realisation of its natural wealth and potential, and their sustenance and protection.

*Stephen Champion, 1993*

# THE HAMSA PUTTUWA

The Hamsa is the sacred swan of Hinduism, where it represents discernment, being able, as the bird of Svarga Loka, to drink the milk only from a vessel of milk mixed with water. The name also stands for beautiful gait and it is regarded as auspicious. In poetry, especially erotic, it symbolises the breasts of women, and women themselves, the resemblence between a swan and a beautiful girl being a common motif in Indo-Aryan folk-lore. In Sinhalese, as in Hindu decorative arts, the Hamsa is everywhere to be seen.

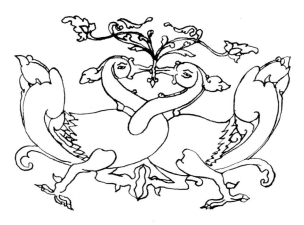

*There are moments of balance. The elements assist in a birth or a death.*
*Regeneration is assured through nature's cycle. Balance is delicate.*
*The soil rich.*

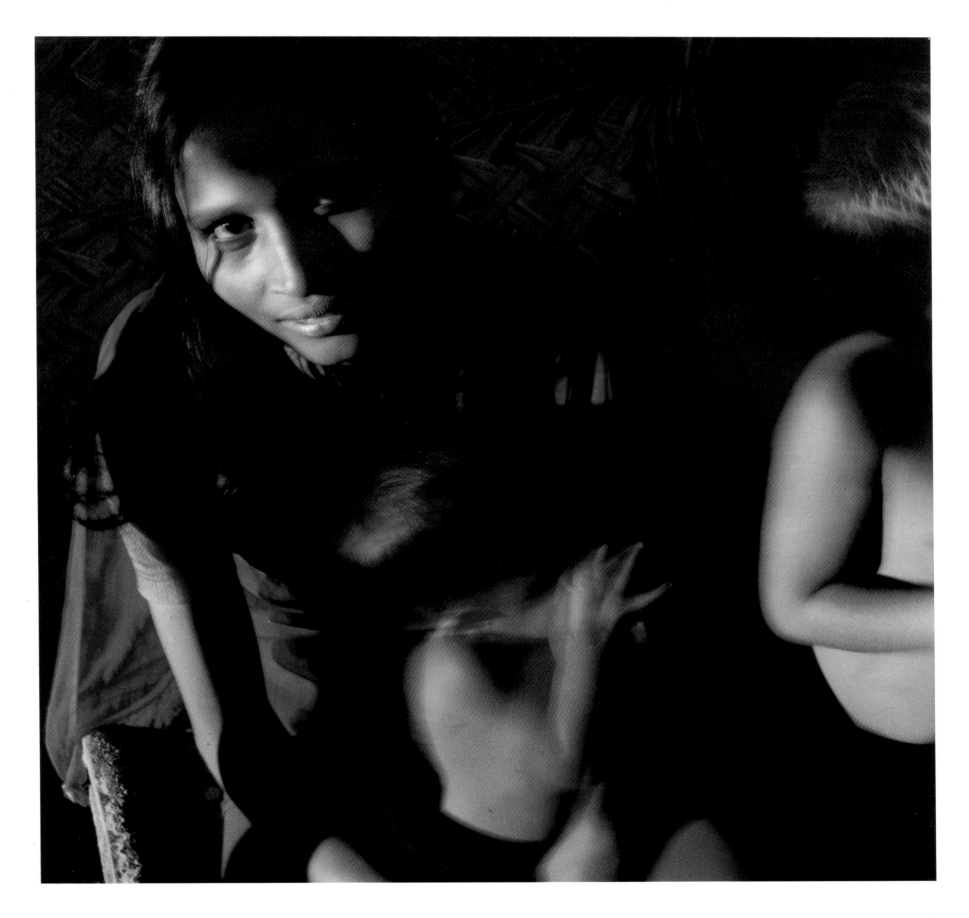

Woman with her children, Pottuvil.   9

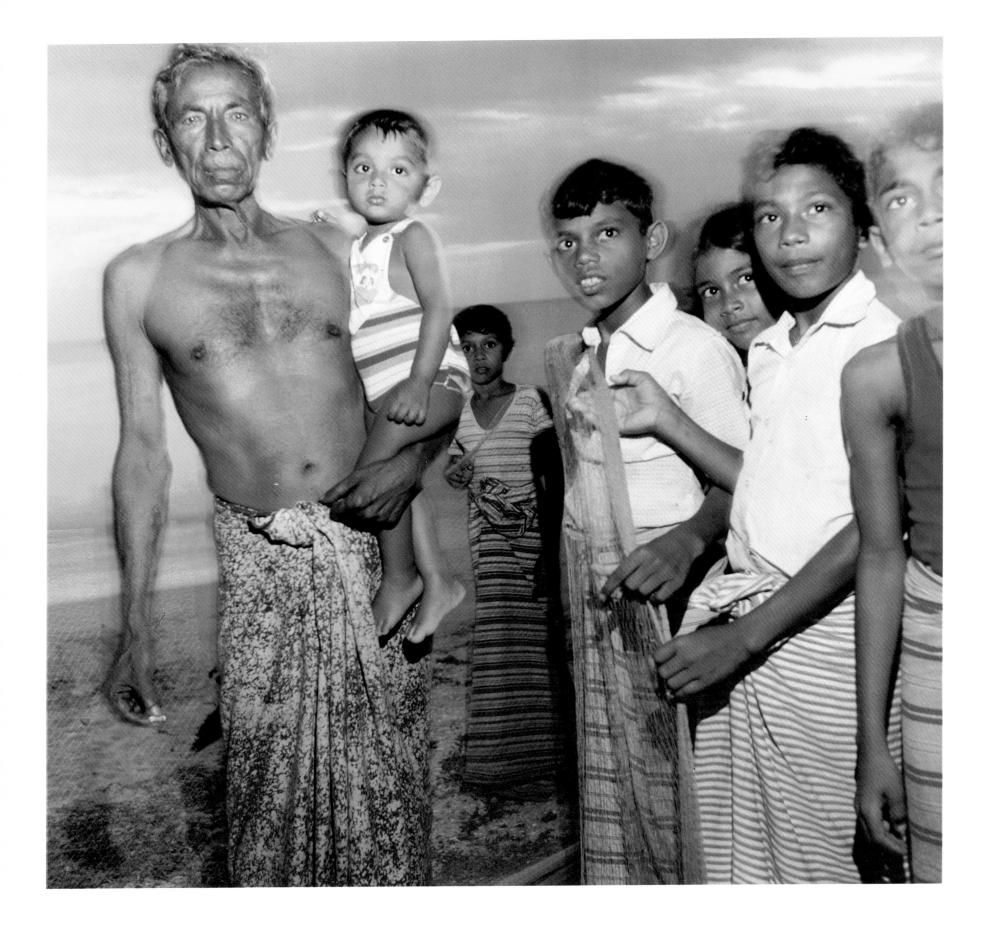

10  Fishing folk, Mirissa.

Funeral pyre, Mirissa.    11

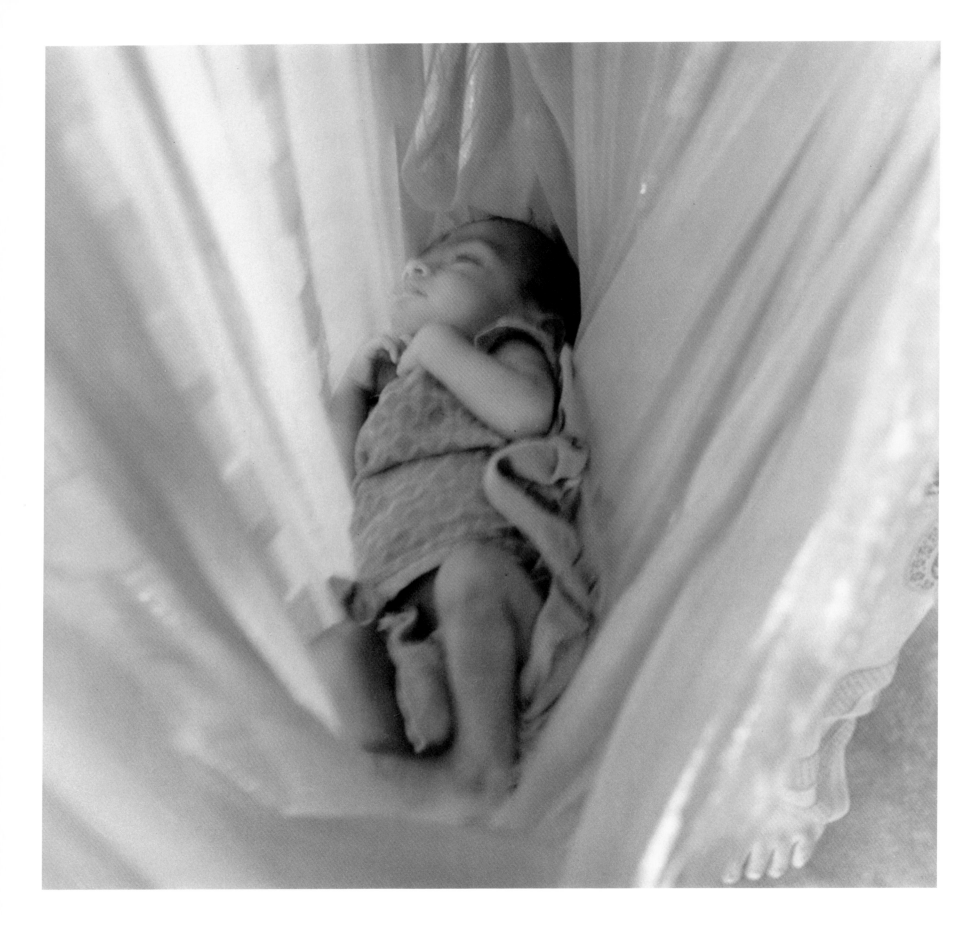

12  Baby sleeping in sari, Maskeliya.

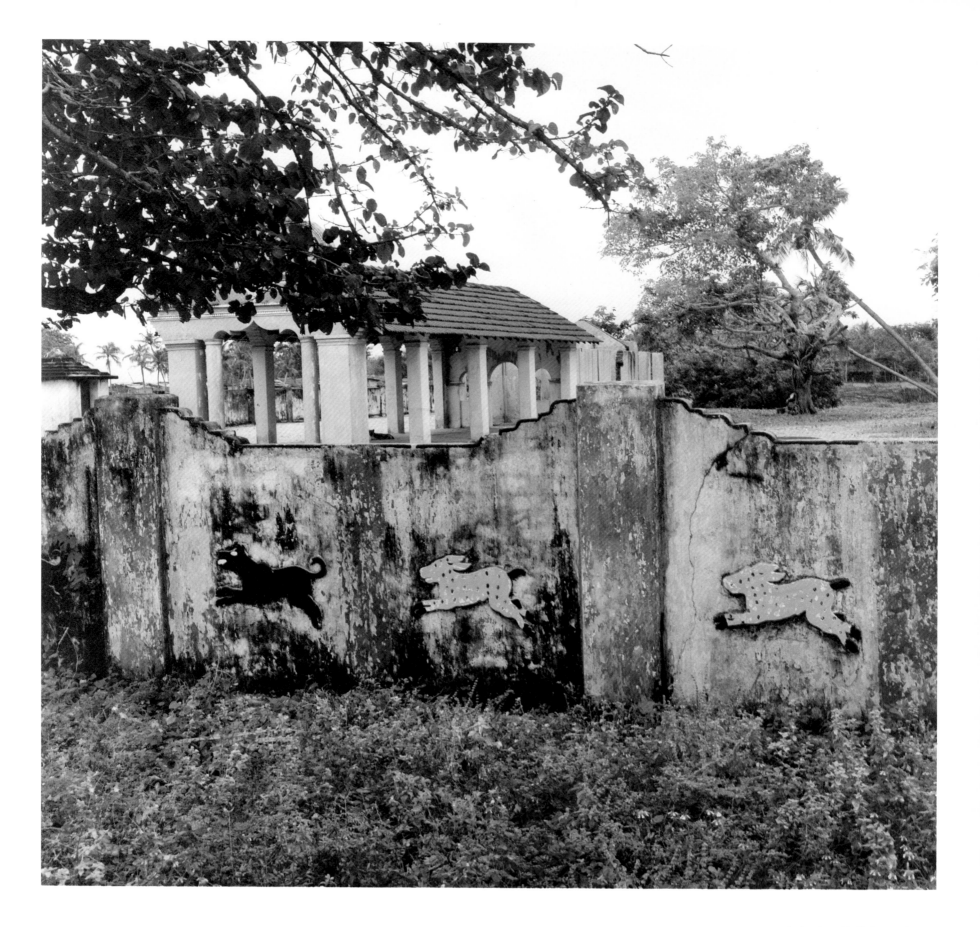

Animal wall, Kalmunai. 13

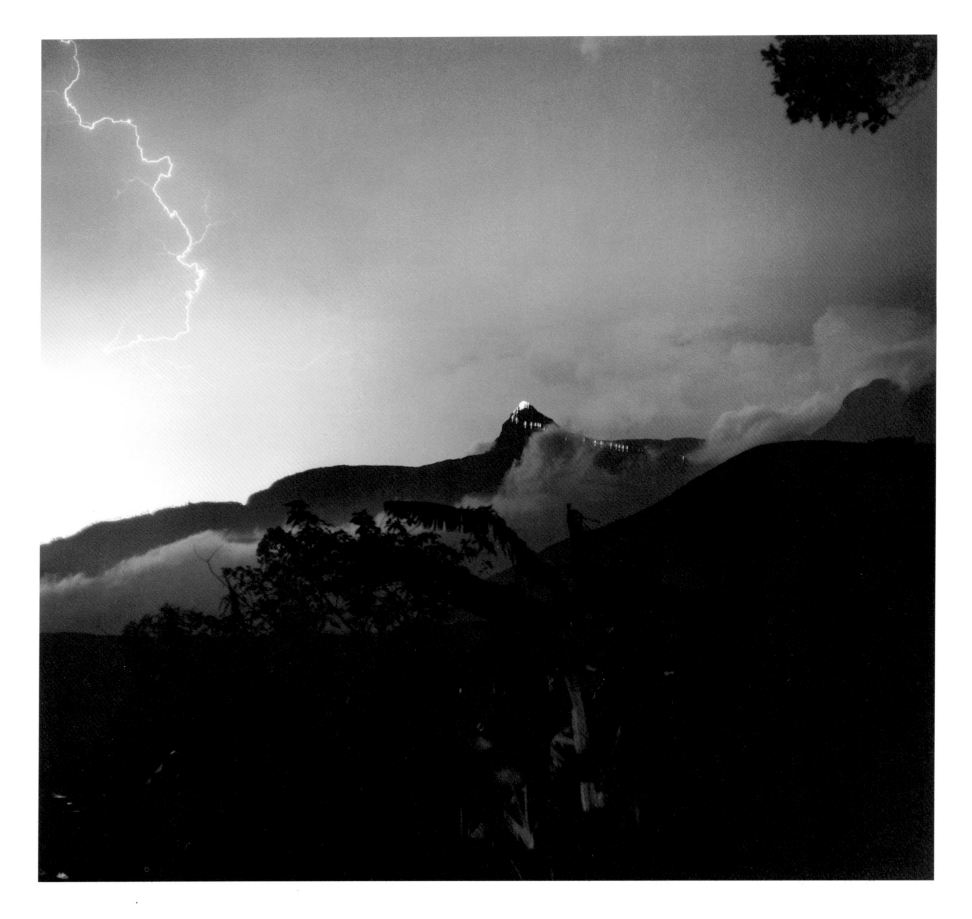

14   Sri Pada, the sacred footprint, or Samantakuta, region of the guardian god Saman, is the pilgrimage centre of Sri Lanka. According to popular Buddhist, Hindu, Muslim and Christian belief, the footprint at the summit is the footprint of the Buddha, Lord Siva and Adam. It is affectionately known as Samanalakande, the Butterfly Mountain.

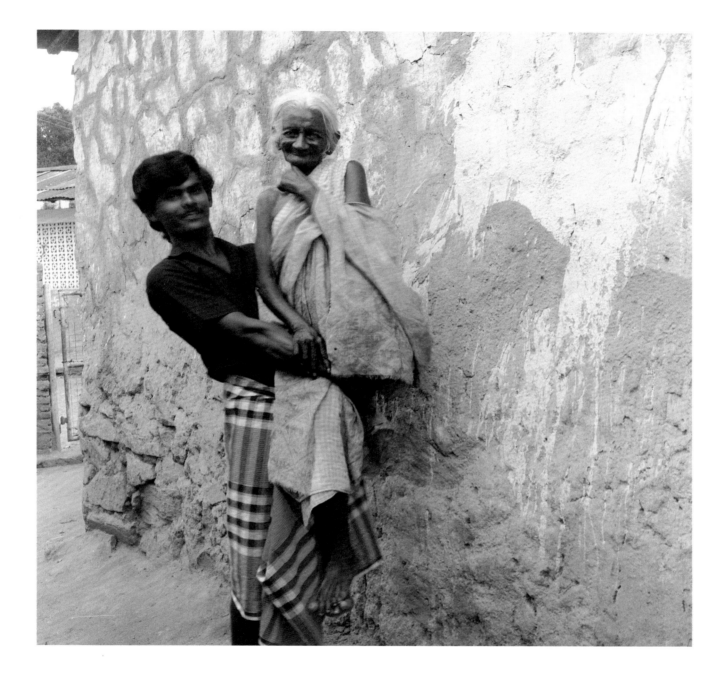

Young man holding his grandmother, Kandy.    15

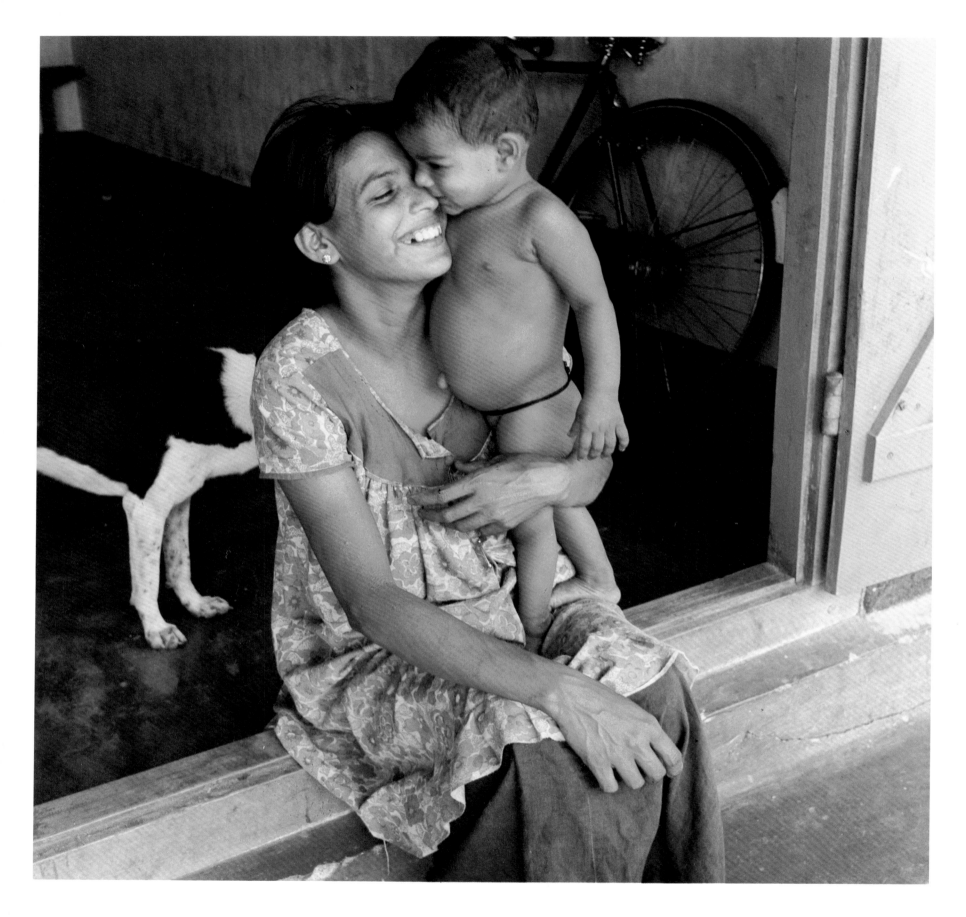

16  Mother and child, Vavuniya.

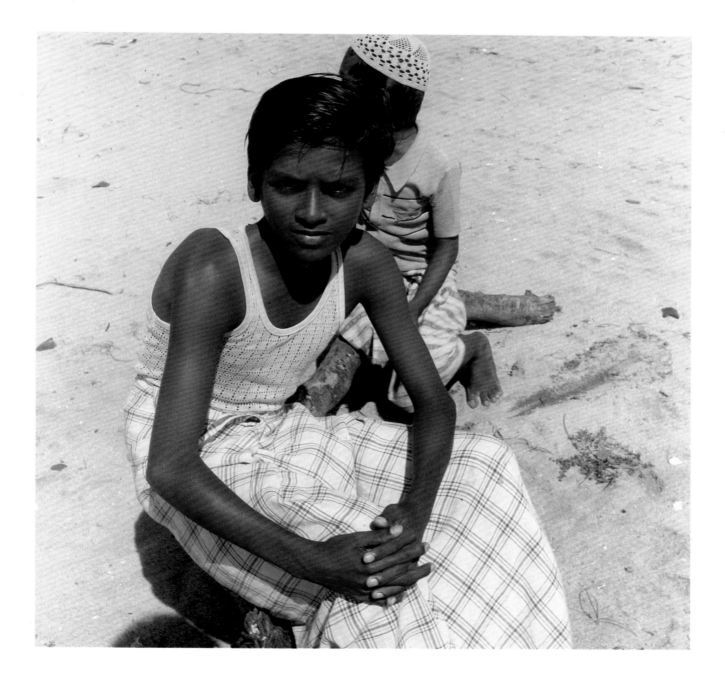

Young men, Pottuvil.   17

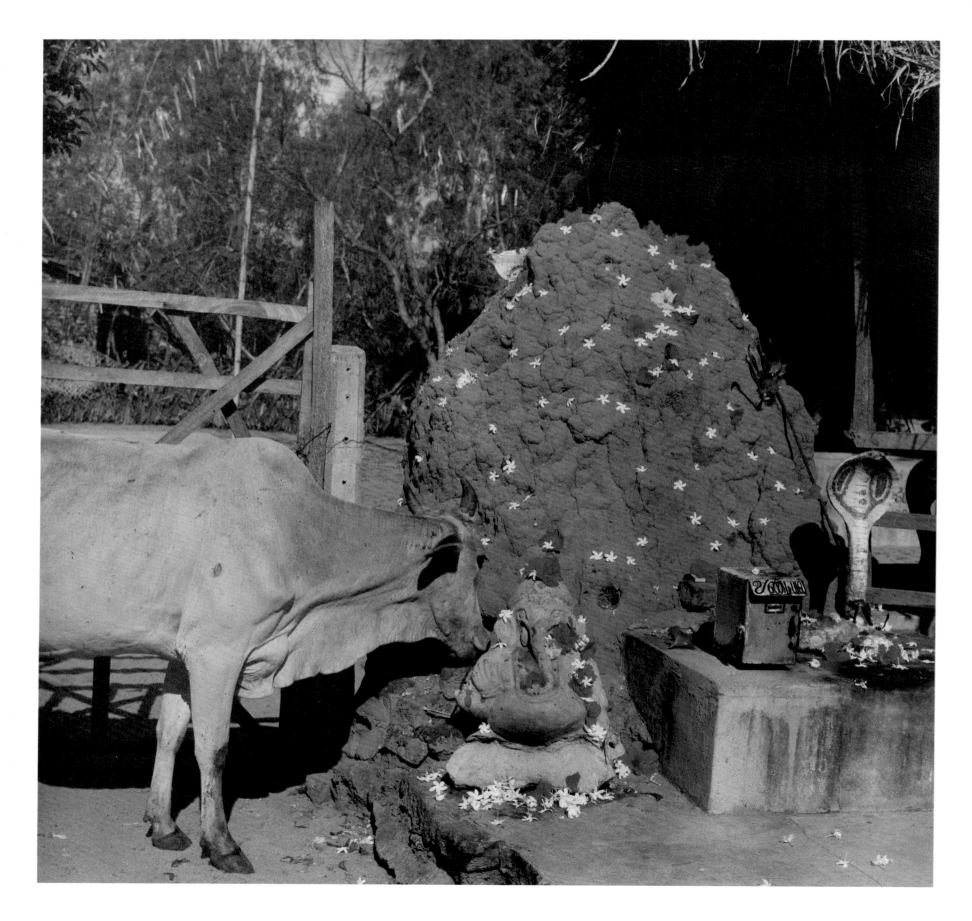

18   Termite hill converted by villagers into a shrine, with flower petals showered as offerings for Lord Ganesh, and breakfast for a passing cow, Kallawanchakudy.

Train passenger asleep with a flower in his mouth.   19

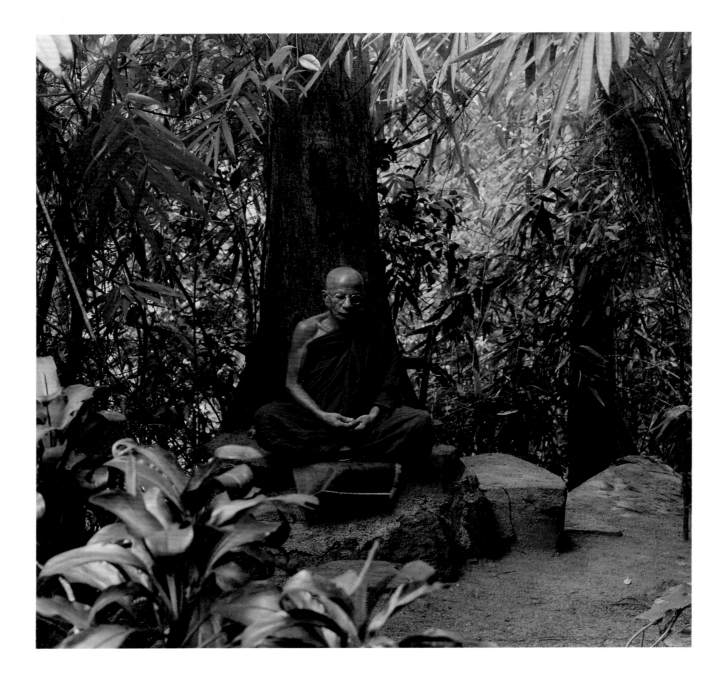

20  Hermit, Ingiriya.

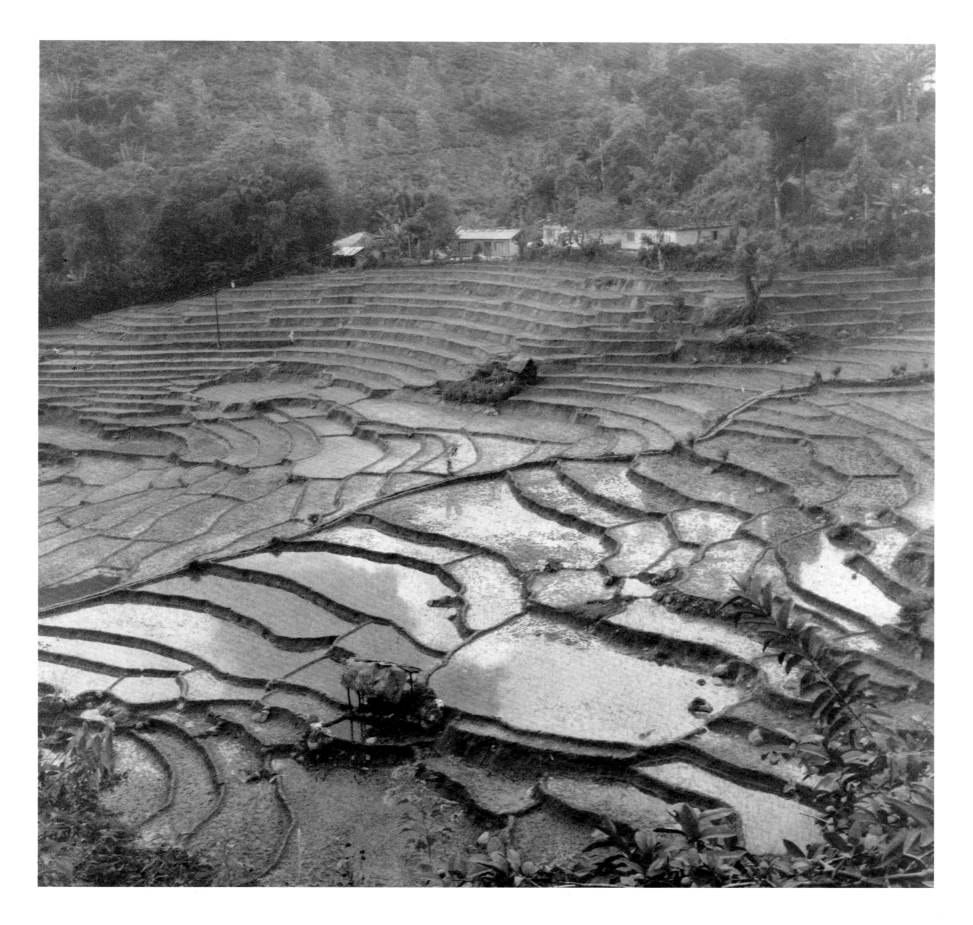

Paddy terraces, Bandarawela.  21

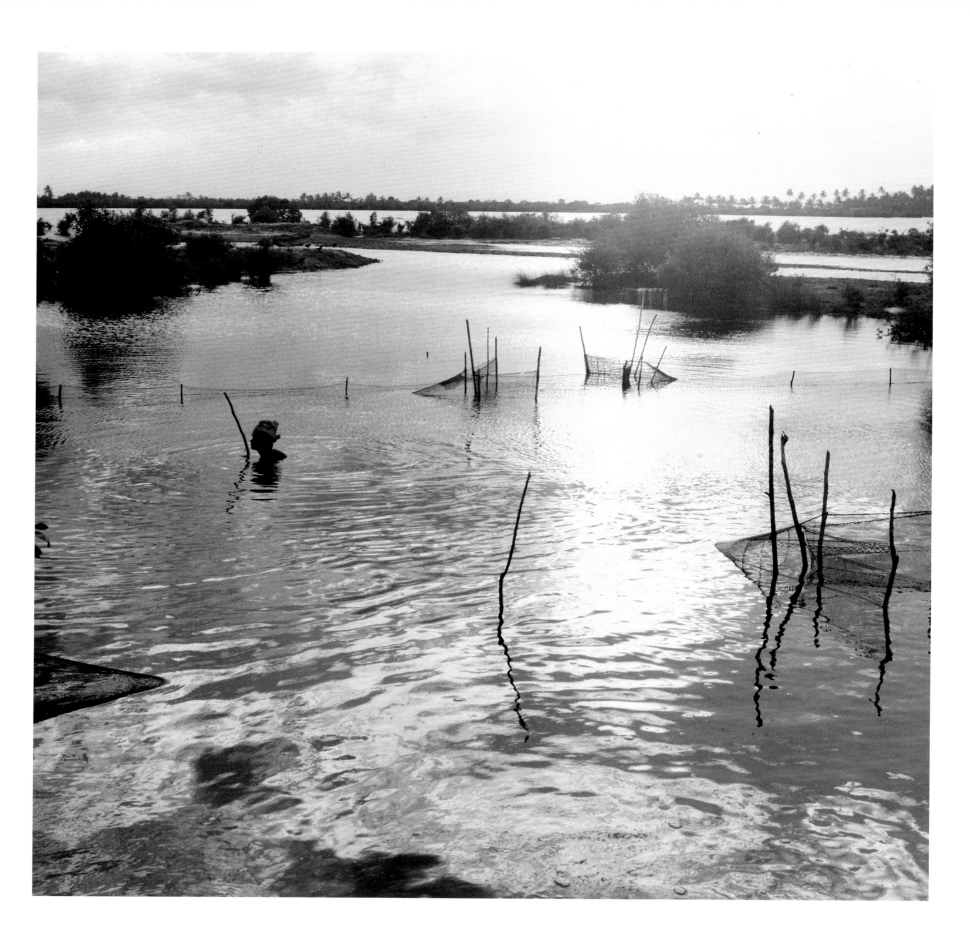

22  Prawn fisherman, Udappuwa.

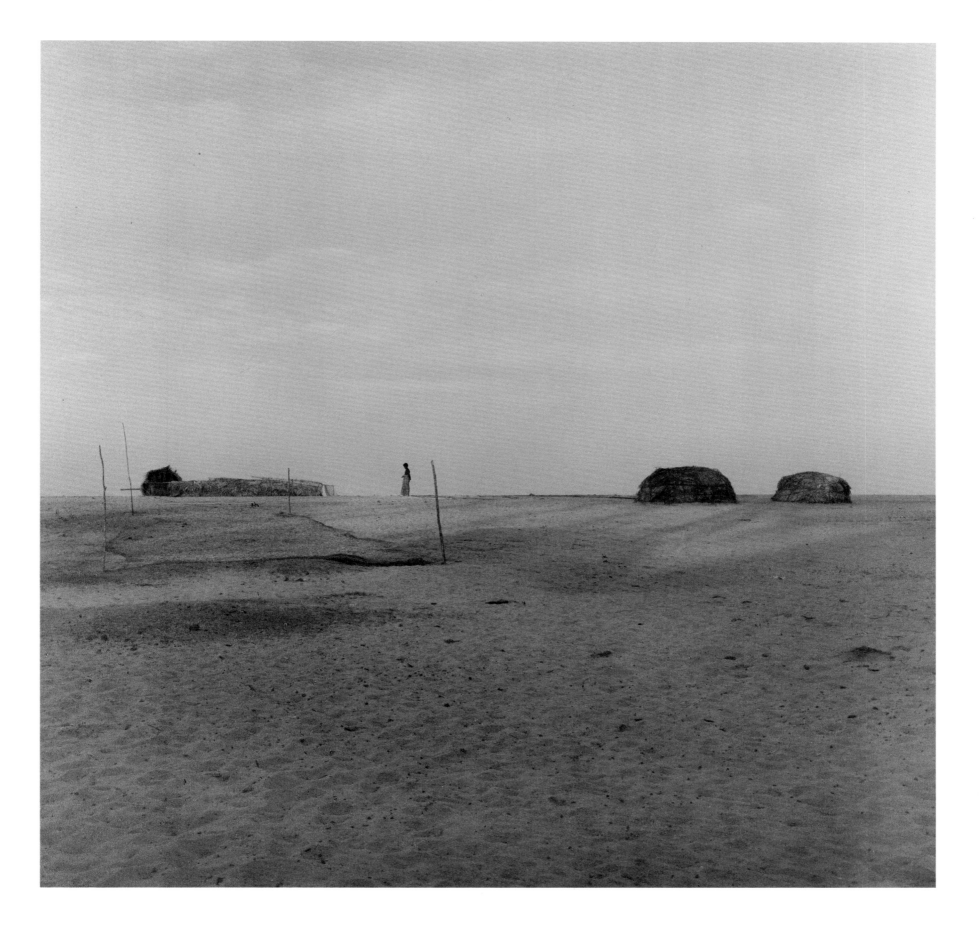

Dusk, Udappuwa.  23

24   Portrait of a woman, Weligama.

Boy running in sarong, Point Pedro.   25

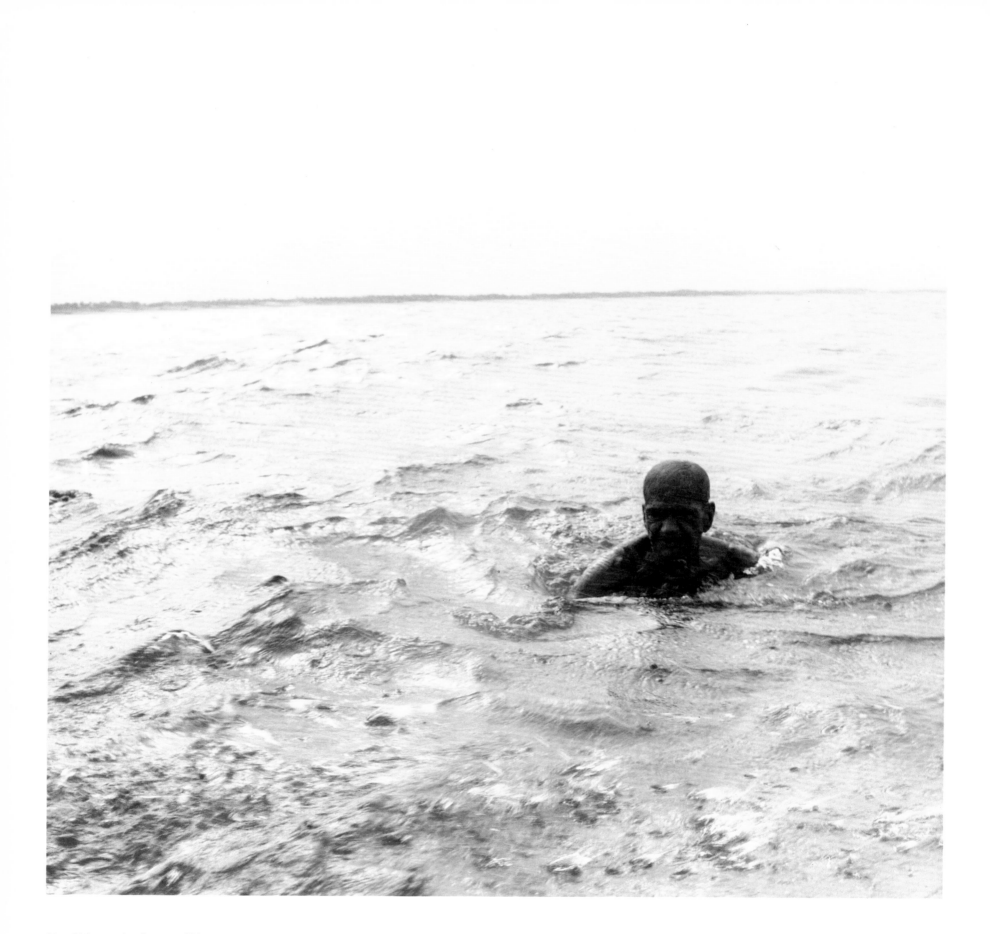

26   Old man in the sea, Udappuwa.

# ART, MAN AND MANUFACTURE

"Culture originates in work, not in play; and man's activity consists in either a making or a doing. Both of these aspects of the active life depend for their correction upon the contemplative life. The making of things is governed by Art, the doing of things by prudence. Manufacture is for use and not for profit. It would be superfluous to say that from the traditional point of view there could hardly be found a stronger condemnation of the present social order than in the fact that the man at work is no longer doing what he likes best but rather what he must and in the general belief that a man can only be really happy when he gets away and is at play. For even if we mean by 'happy' to enjoy the 'higher things of life', it is a cruel error to pretend that this can be done at leisure if it has not been done at work. For 'the man devoted to his own vocation finds, perfection … That man whose prayer and praise of God are in the doing of his own work perfects himself'. It is this way of life that our civilisation denies to the vast majority of men, and in this respect that it is notably inferior to even the most primitive or savage societies with which it can be contrasted. Manufacture, the practice of an Art, is thus not only the production of utilities but in the highest possible sense the education of men.

If industry without Art is brutality then the industrial worker is a 'brute'. How so? By virtue of the fact that the working classes under the existing conditions of production have 'nothing to offer and sell but their physical strength and skill' which is the definition of a prostitute, or anybody 'kept'. No wonder if the workman's body 'having lost, in his own eyes, well nigh all its importance as an instrument of skilled production, interests him almost exclusively as a source of pleasure and discomfit'.

I specified above the 'worker for wages', meaning the hired and fired man, because as has often been pointed out, the normal workman is not a merchant of himself or his product, but only sells the latter in order to obtain the means of going on with the work with which he is in love and for which he is responsible to himself and to his neighbours. The division of the artist from the artisan, of fine from applied Art, corresponds exactly to the current opposition of liberal to technical education and of learning to manual skill, as if these were incompatibles. In fact in the industrialised democracies whether totalitarian or capitalistic, there has developed a class distinction which divides those who can be gentlemen artists from those who can live only by an artless industry and are expected to enjoy the 'higher things' of life (if at all) only in their hours of 'leisure' or to speak more accurately 'idleness', since leisure properly means nothing but freedom to do one's own work unhindered by extraneous compulsions. The man who is earning his living by doing what he would rather be doing than anything else in the world, the free man, is an exception. So as Eric Gill has so often pointed out 'a civilisation denying free will naturally and inevitably produces slaves, not artists', and in such a civilisation few men are artists, and those few are simply lap dogs of the rich and a great fuss is made about them. The factory system is a system naturally growing out of a philosophy which denies free will; and which as a natural consequence has degraded man to a mere tool."

*By Ananda K Coomaraswamy*

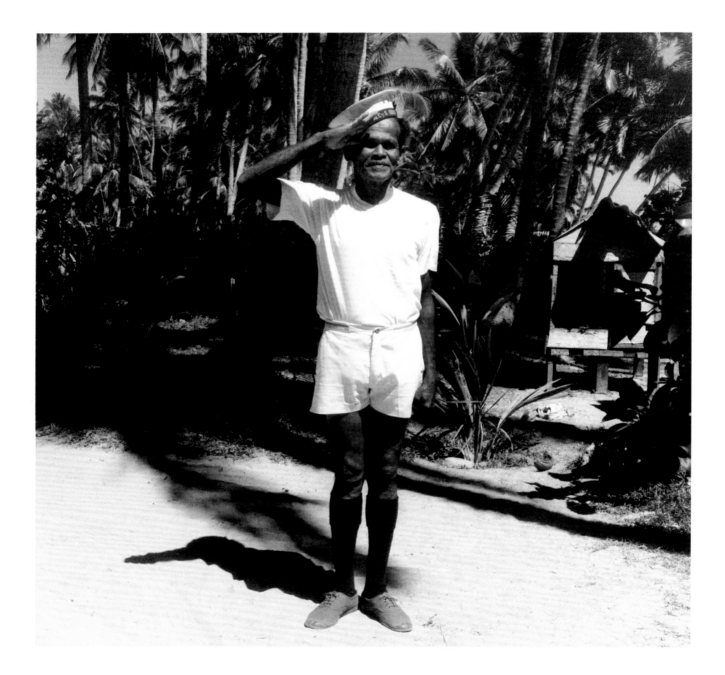

28 Uncle, Mirissa.

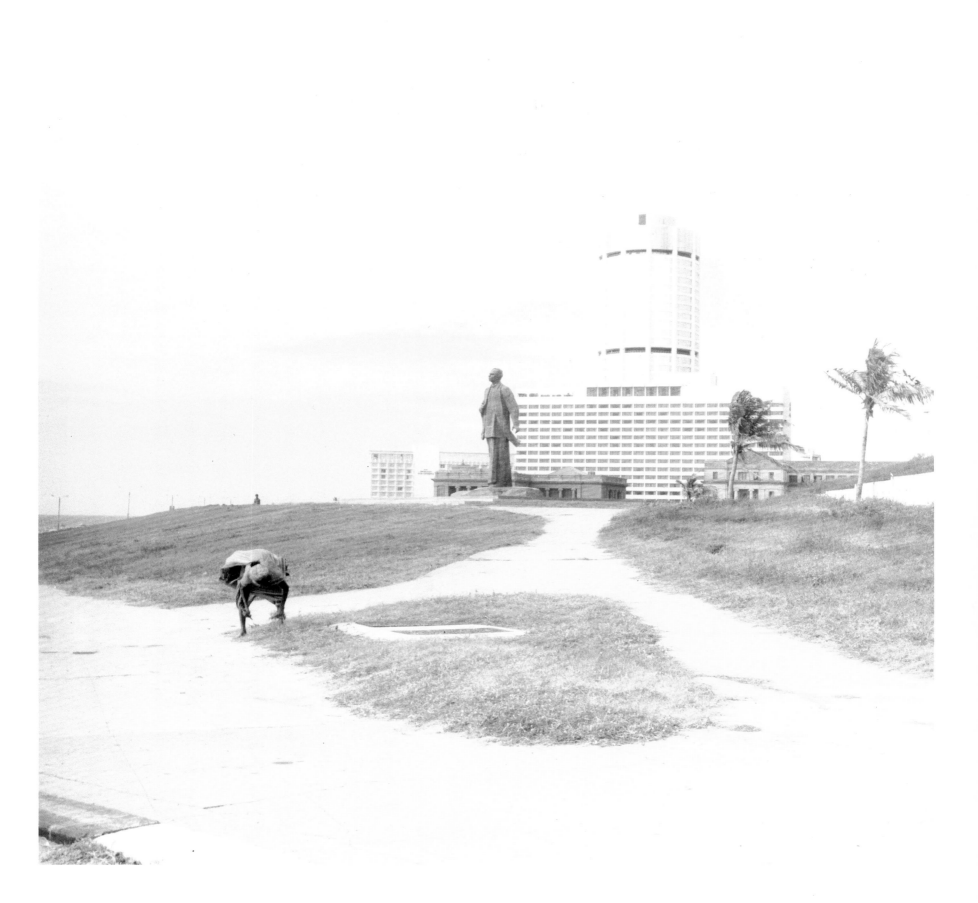

Bank of Ceylon, political monument and a woman picking grass. Democracy, Colombo.  29

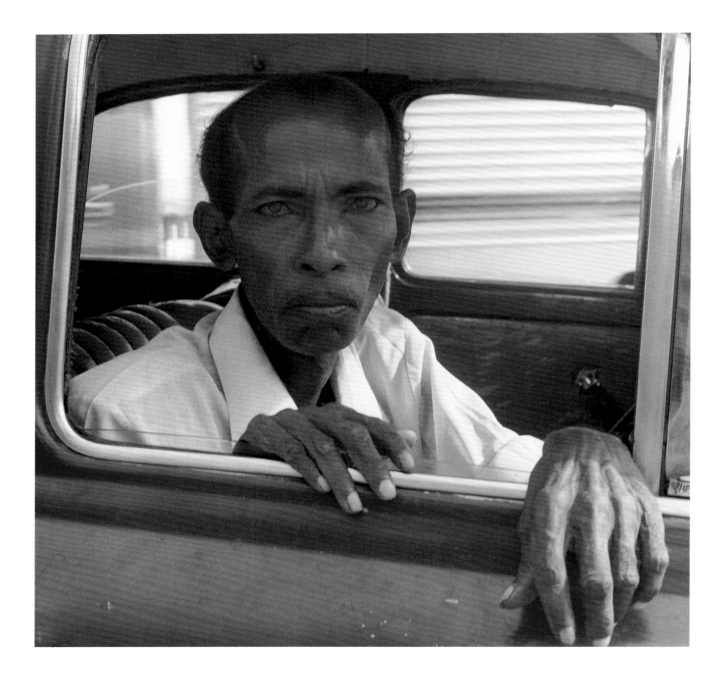

30  Taxi driver, Embilipitiya.

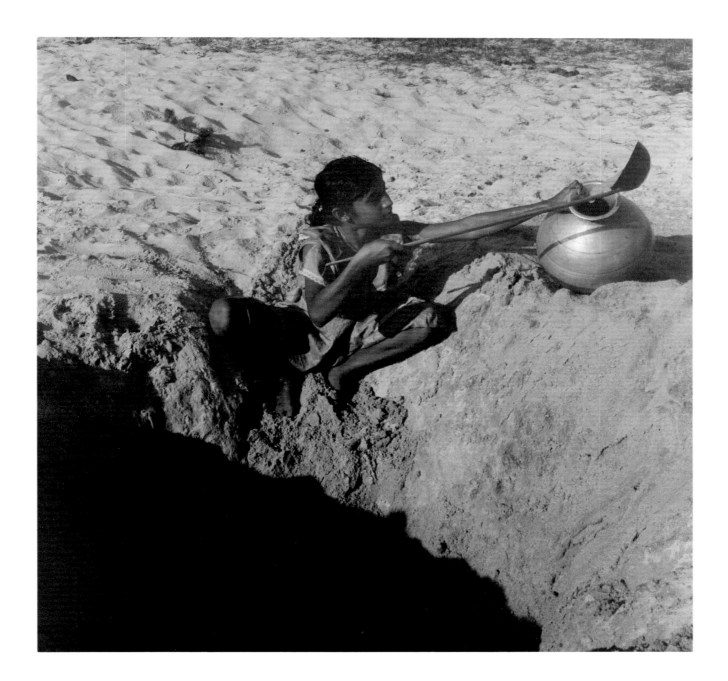

Girl collecting water, Udappuwa.　31

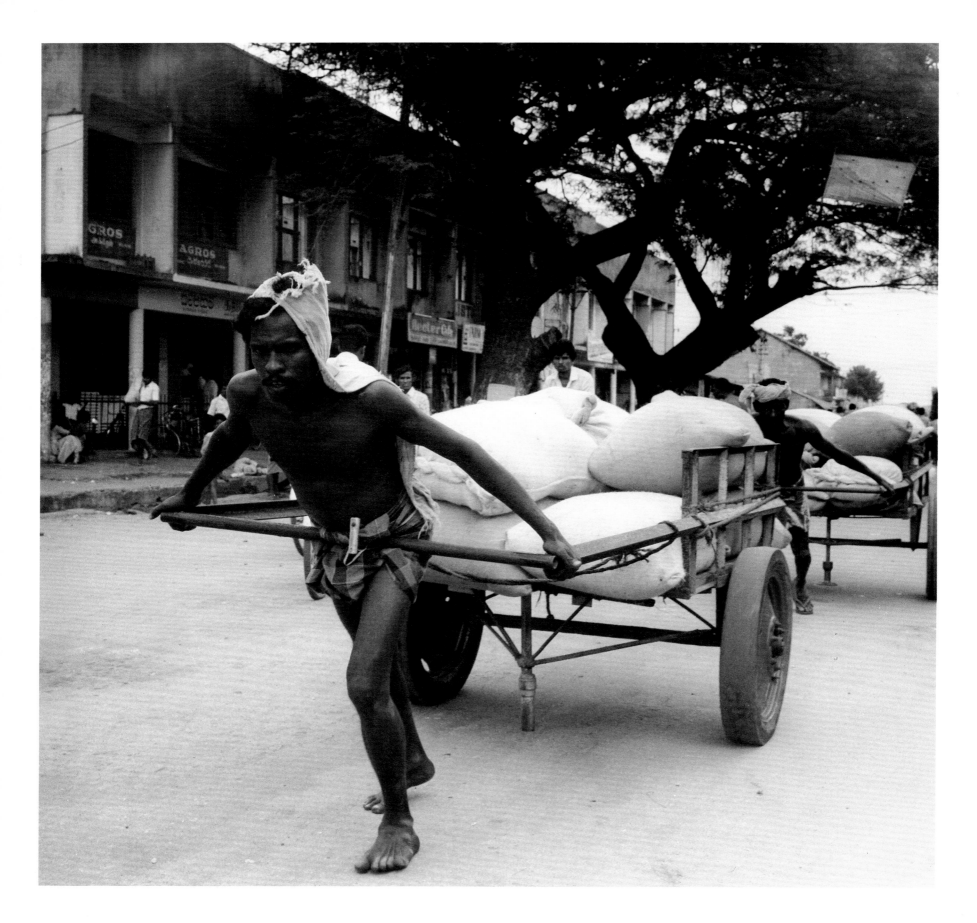

32  Man pulling cart, Vavuniya.

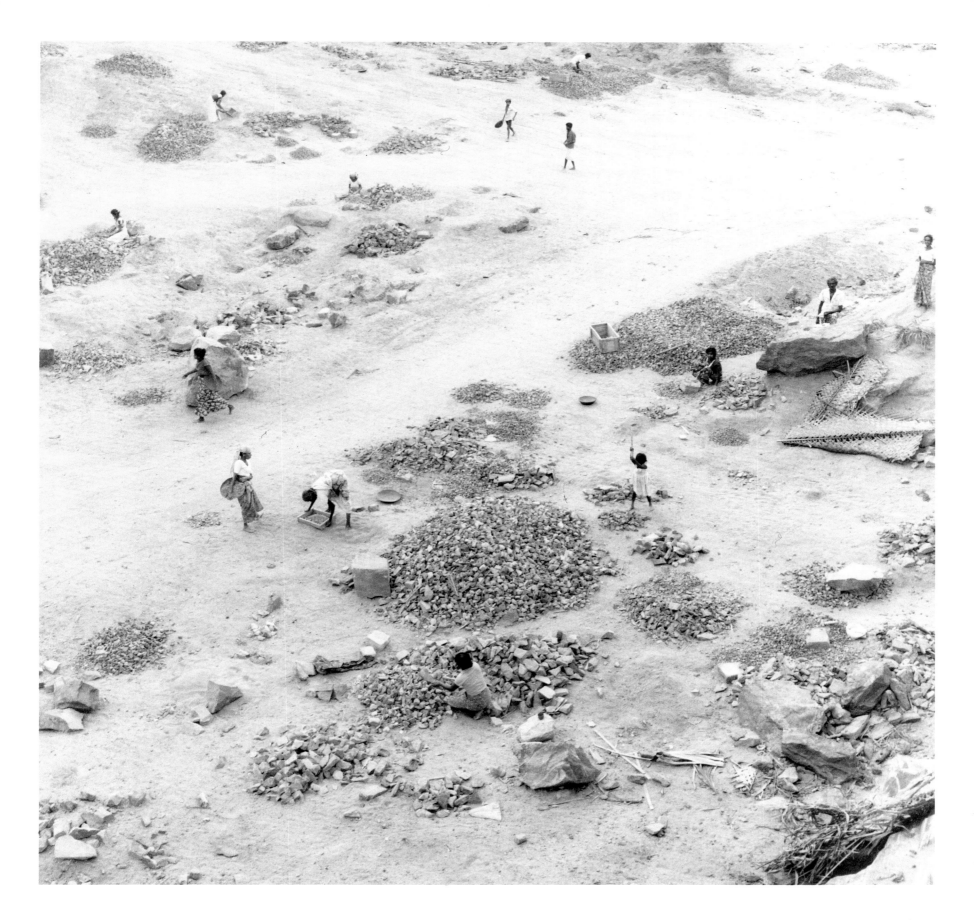

Breaking rocks into little pieces, stone quarry, Peradeniya. 33

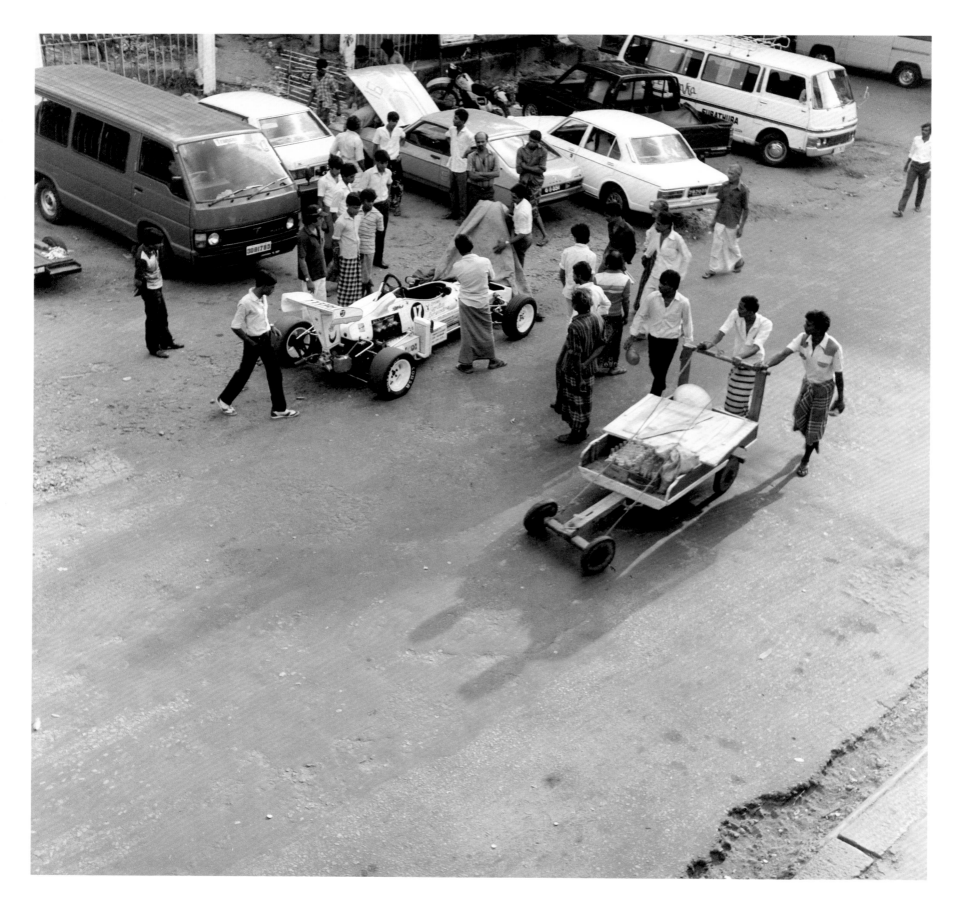

34   Formula 1, Formula 2, Kandy.

# A MUDALYAR COURT DIGNATORY,
## FLANKED BY TWO EUROPEANS AND QUEEN VICTORIA

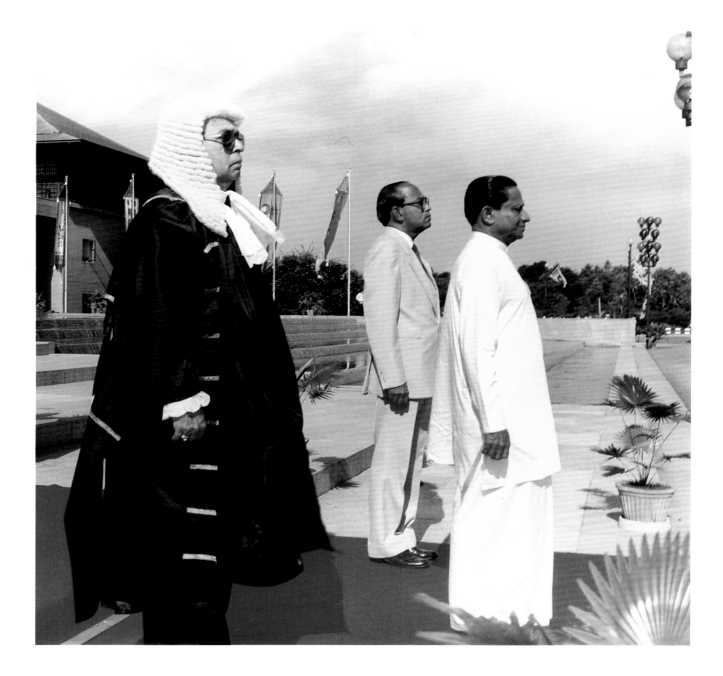

36   President R. Premadasa at the opening of Parliament, Kotte.

38  Old boys at the Royal – Thomian cricket match, Colombo.

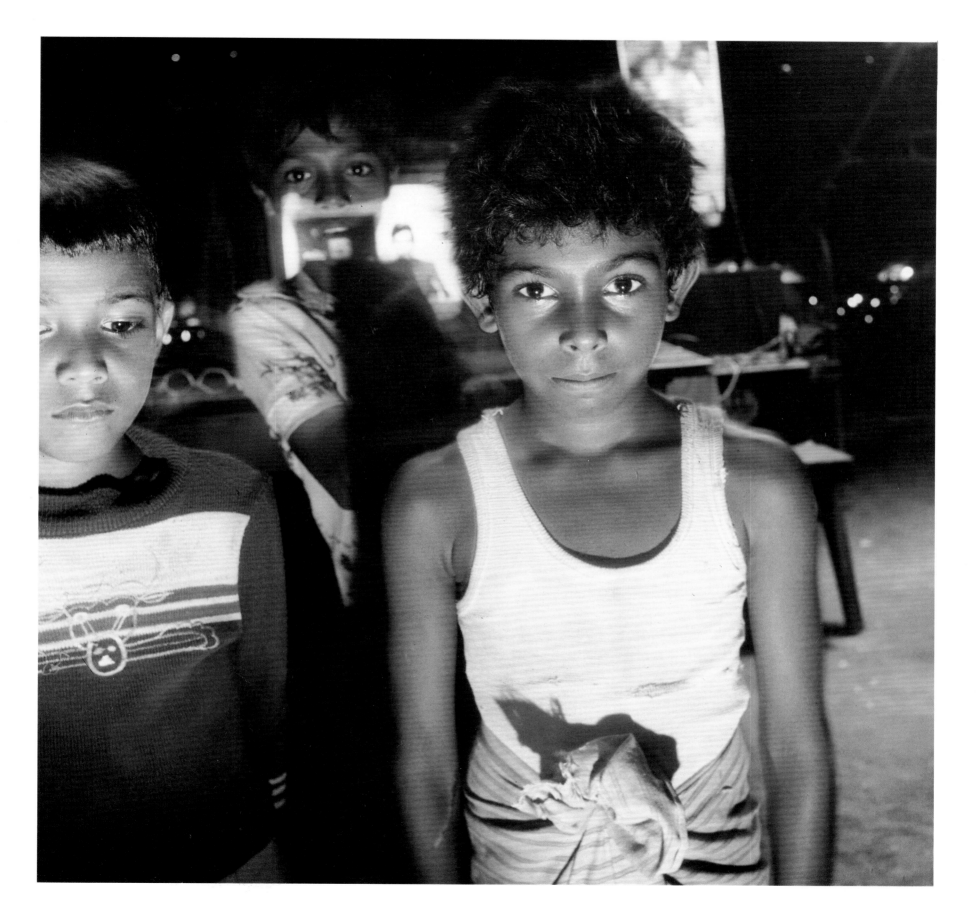

T.V. kids, Colombo. 39

40  Fashion show, Colombo.

Bathroom, Colombo.  41

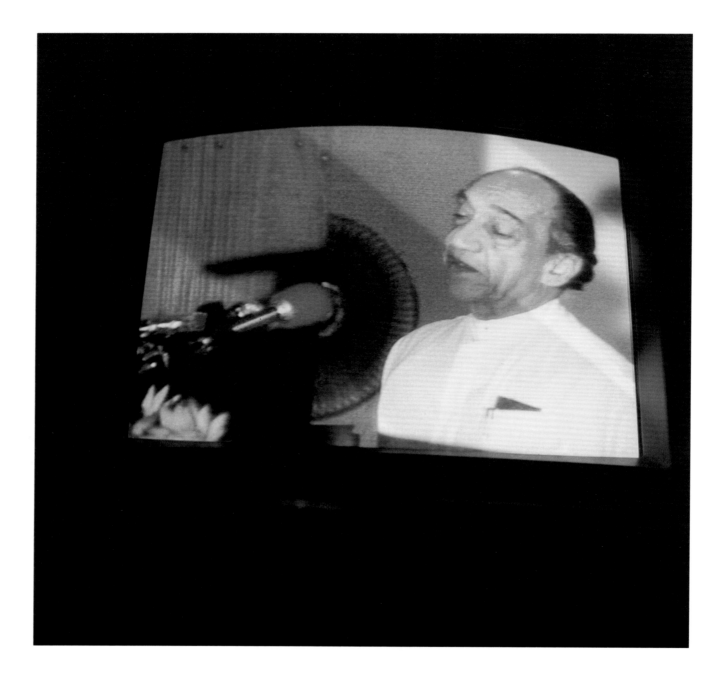

42    Former President J. R. Jayawardene on television, Kalmunai.

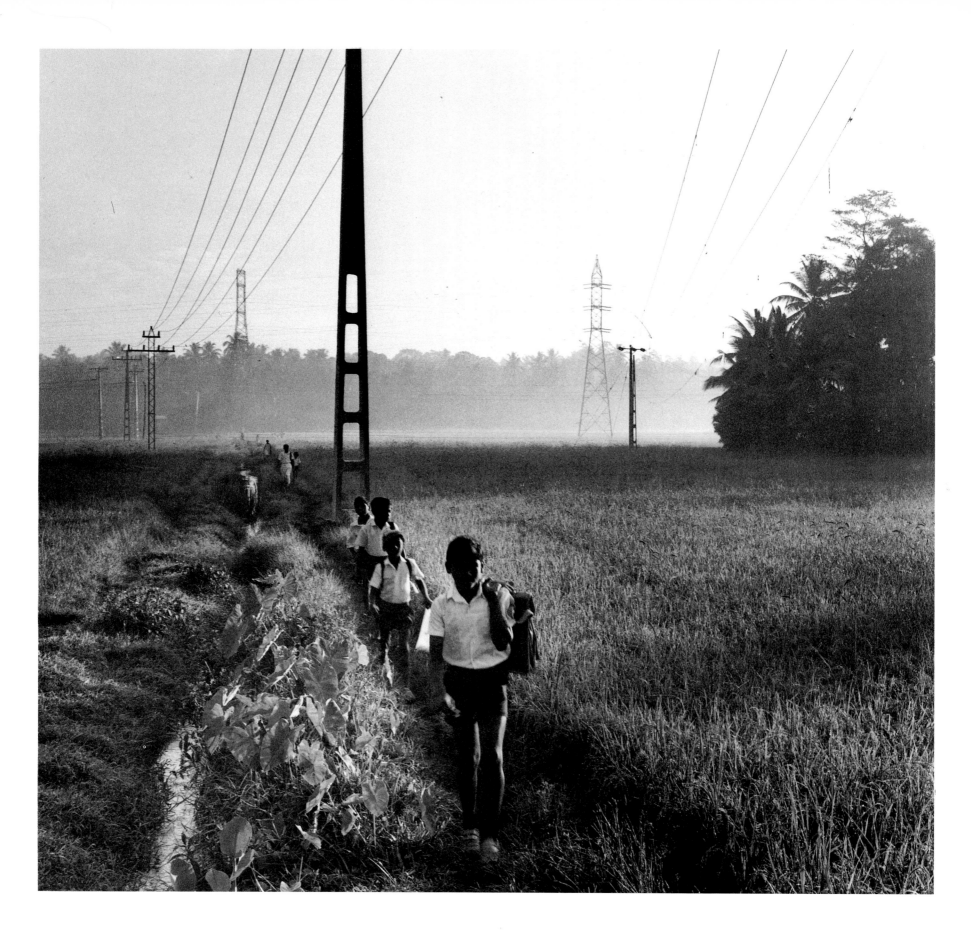

44    Children walking to school in the early morning.

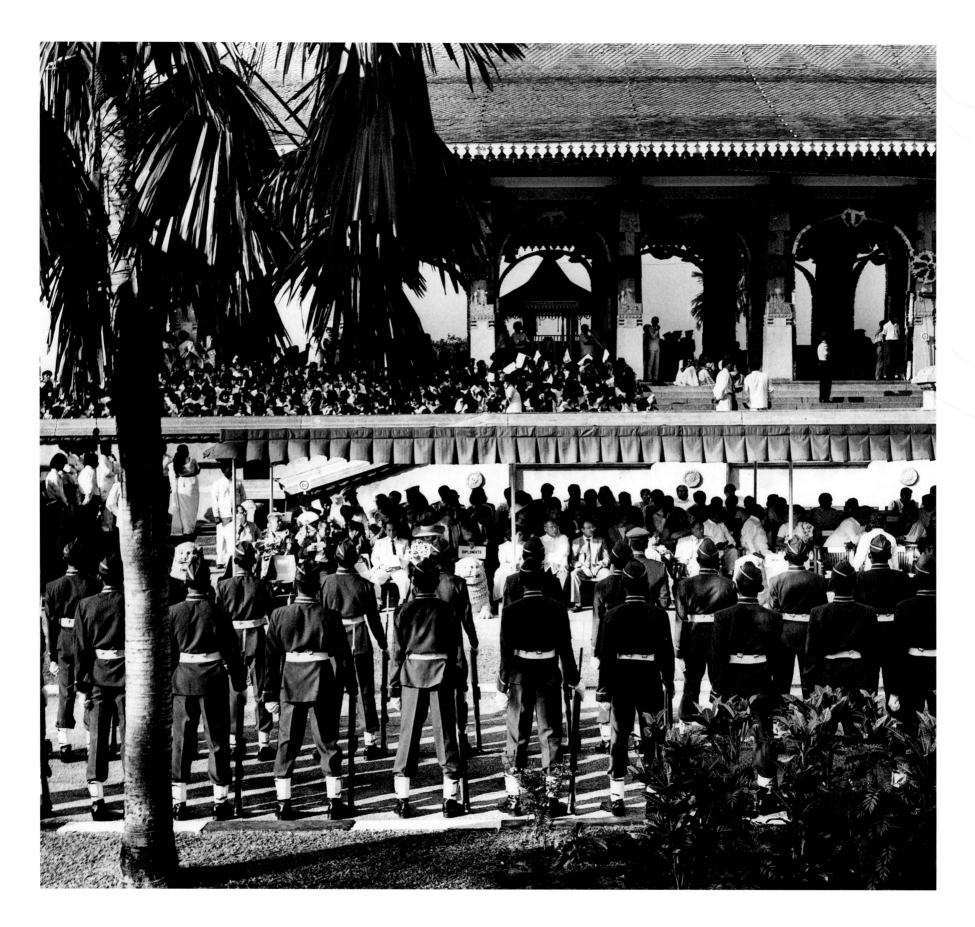

Independence Day, Colombo. 45

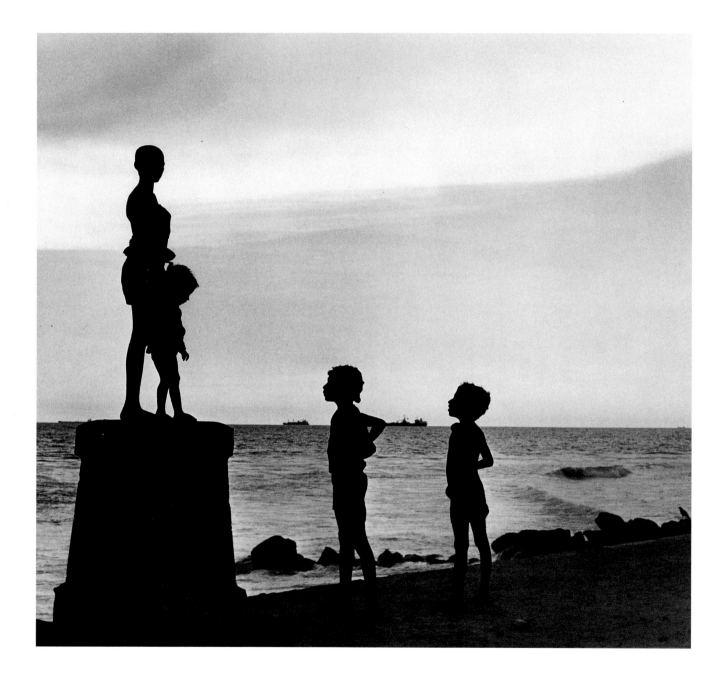

46   Children of Galle Face Green, Colombo.

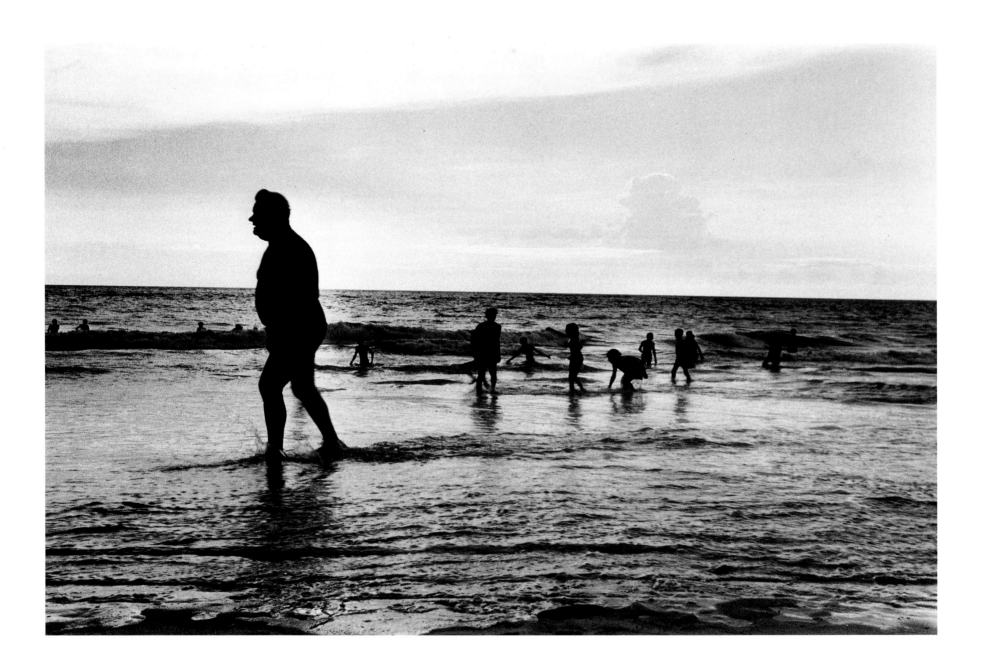

Tourist, Mount Lavinia.  47

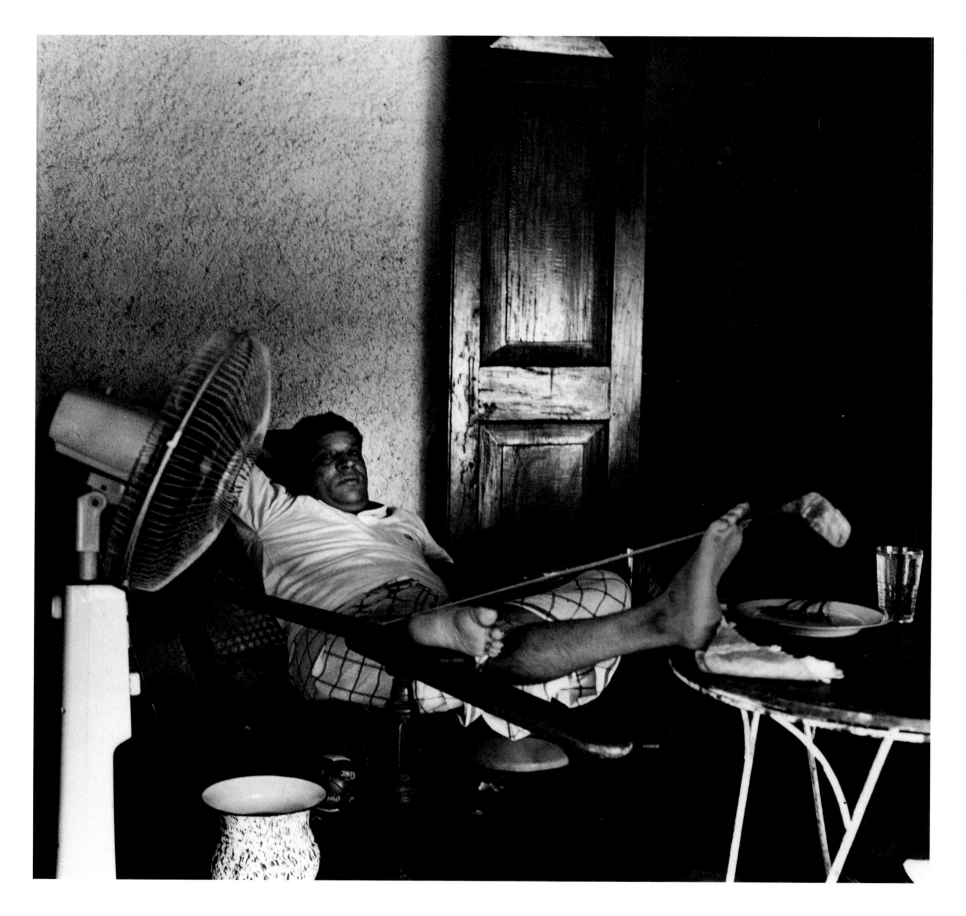

48   A gentleman of leisure with his golf club, Ratnapura.

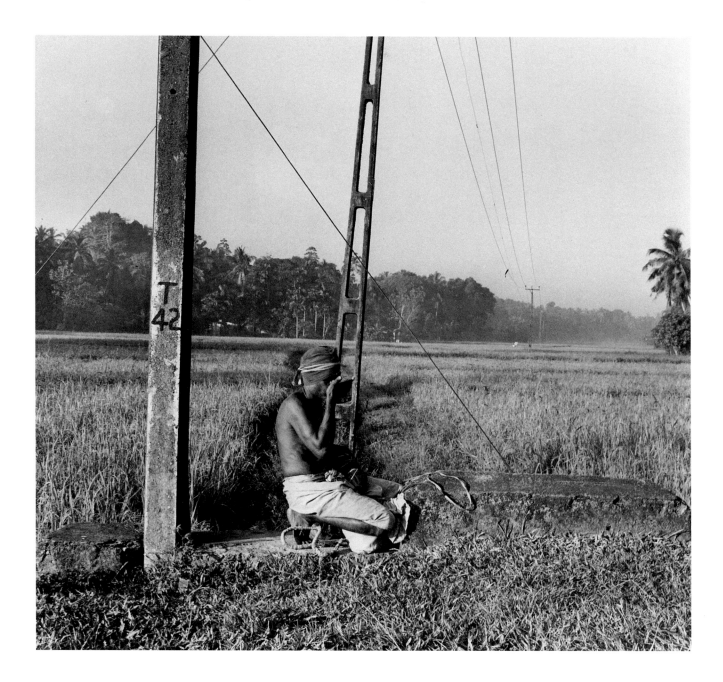

A coconut plucker stops to chew betel on the way to his work. 49

50  Emulation of the mannequin, Colombo.

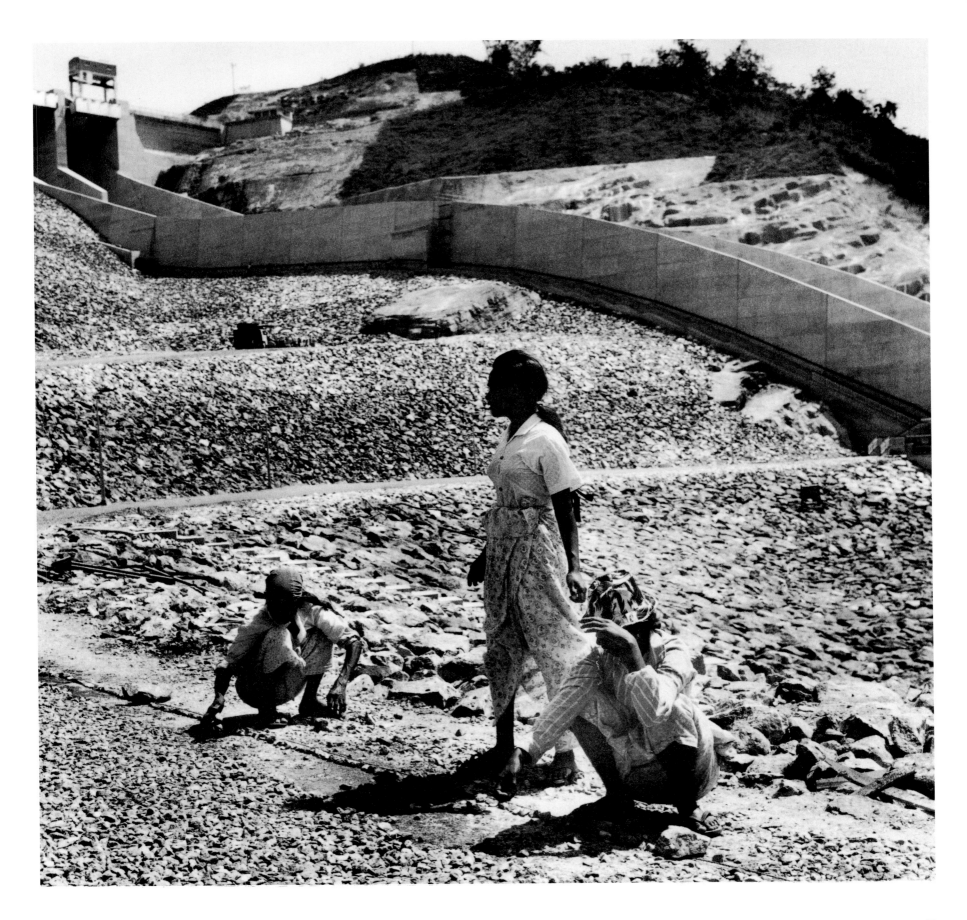

Dam labourers, Samanalawewa.  51

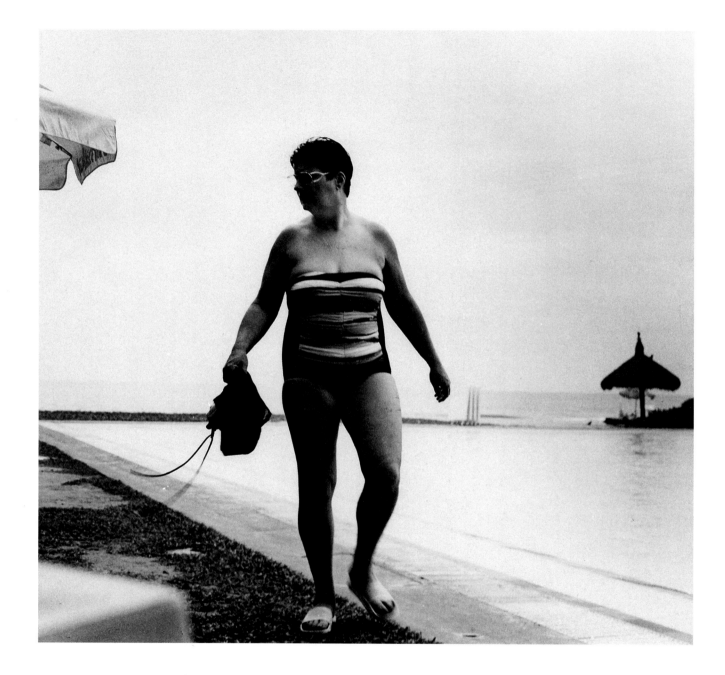

52   Tourist, Ahungalla.

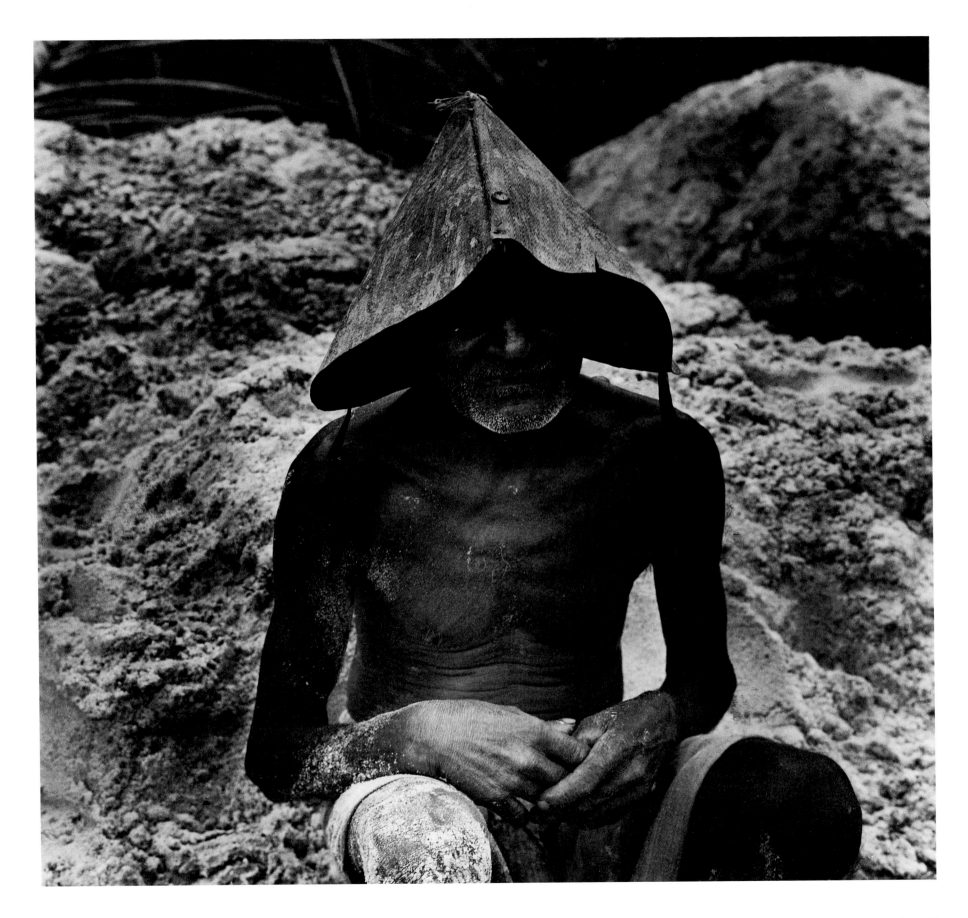

Gem miner, Eheliyagoda.    53

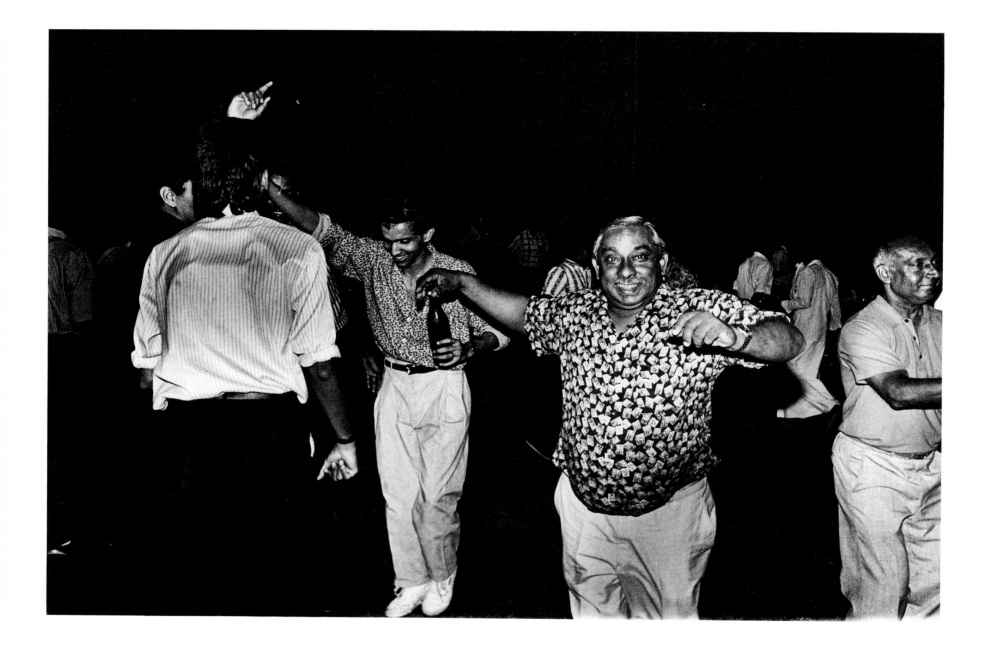

54 Stag night revellers dancing the baila, Colombo.

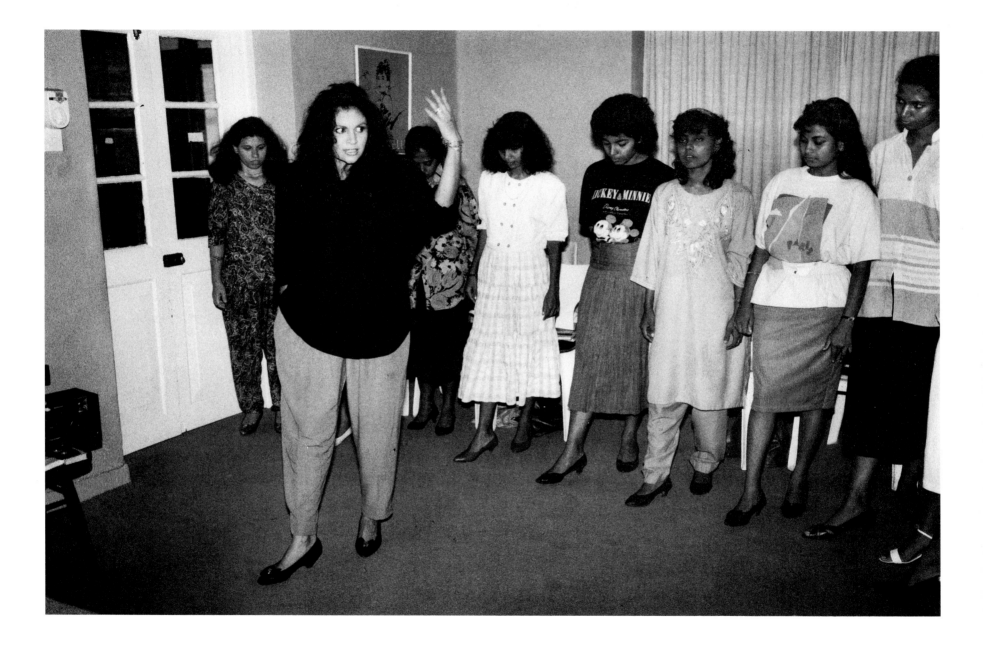

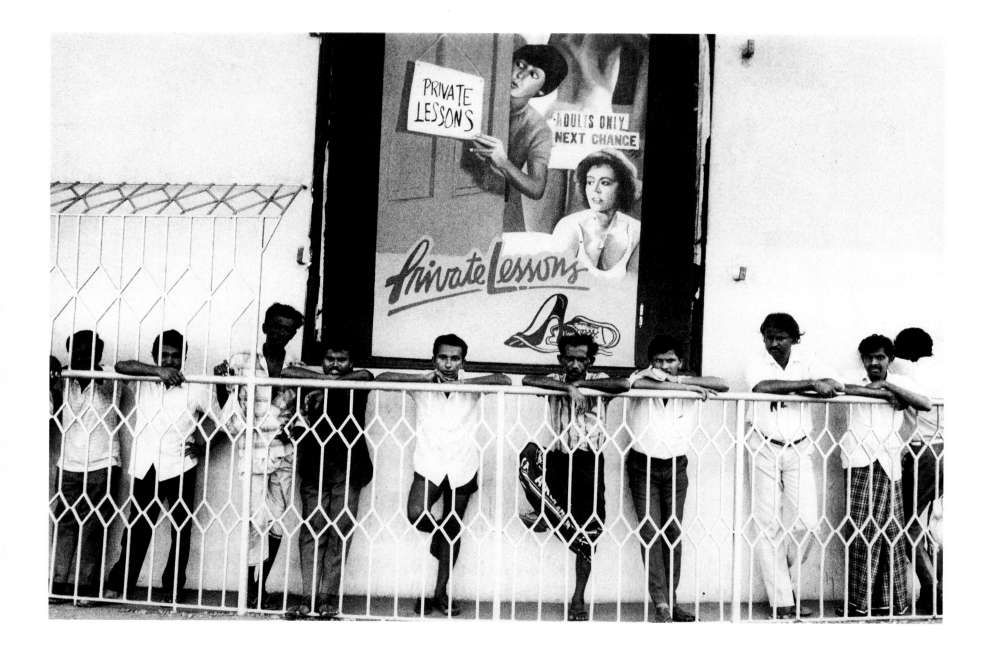

56  Private lessons, Colombo.

# ART, MAN AND MANUFACTURE

The consumer lives in the same world with the producer, whether or not he too produces; and the consumer as such can only obtain for his use what the factory produces, with the exception of the man who can afford to buy custom or handmade goods. Saleability is the criterion of production, and the art of persuasion has been developed to such a pitch that men can be persuaded by skillful advertisement to want any gadget whether they want it or not. Gadgets can be so easily produced in factories in quantities greater than can be sold locally that persuasion – rationalised and justified by the contention or conviction that the creation of new wants is a civilising process – and has to be exported in order to capture foreign markets which are flooded, in their turn, with the standardised products of industrialism, for which those who once worked as vocational artists in their own environment now serve as producers of raw materials. All this is possible, of course, because the strangers, whose own traditions have been broken down by the kind of education that their conquerors have imposed upon them, can, as the native American, be persuaded that the quantitive standard of living will be for their good; and there remain few in power, who can say with the Pasha of Marrakesh that 'we do not want the incredible western way of life' or with Gandhi, defend the pattern of a social order composed of free individuals, where there would be no need for the institutions that concentrate power into the hands of oligarchies or of that kind of technocratic control of nature which really means nothing but the control of the majority by a minority possessed of the most efficient means of coercion by violence.

*By Ananda K Coomaraswamy*

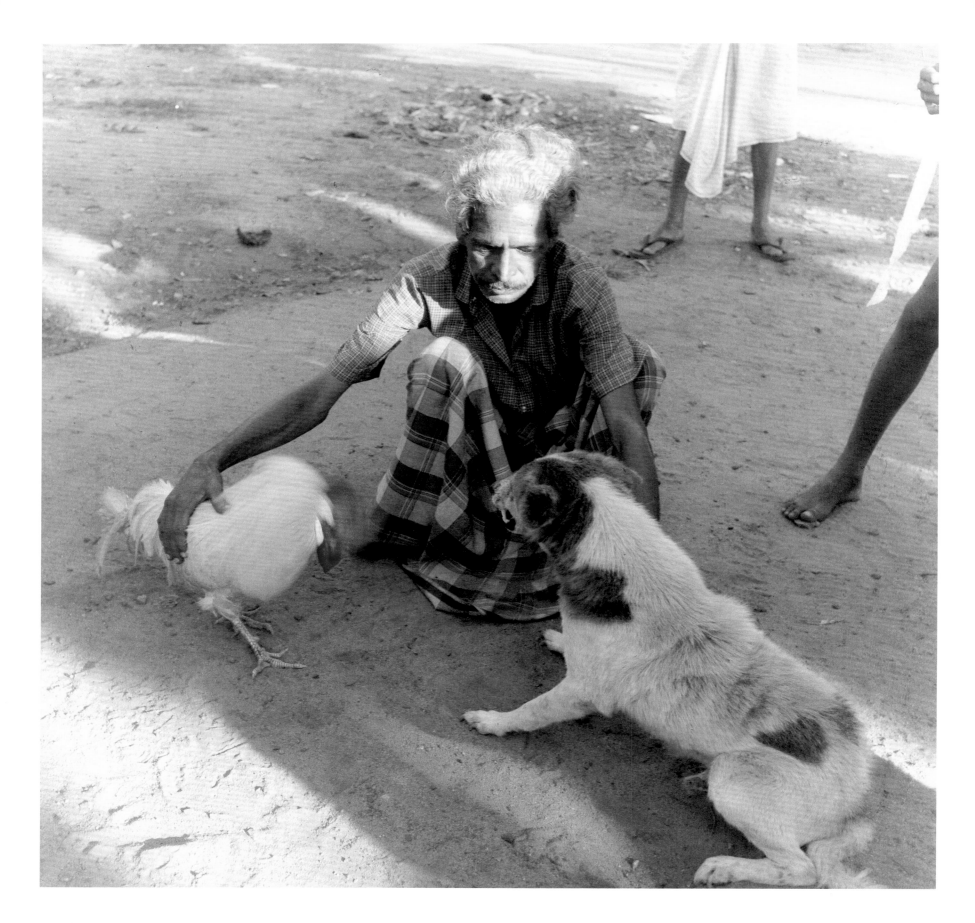

58  Man with his reincarnated son and dog, Colombo.

# THE YAMMA RAKSAYA
# THE DEATH DEVIL

## The Security Desk

*Even in his reflection. Cleanliness, so precise, down to the hair's breadth and overlap of nail. Words spat from his mouth and lies of calm and normalcy hung thick in the air. His rifle butt propped up and leaning.*

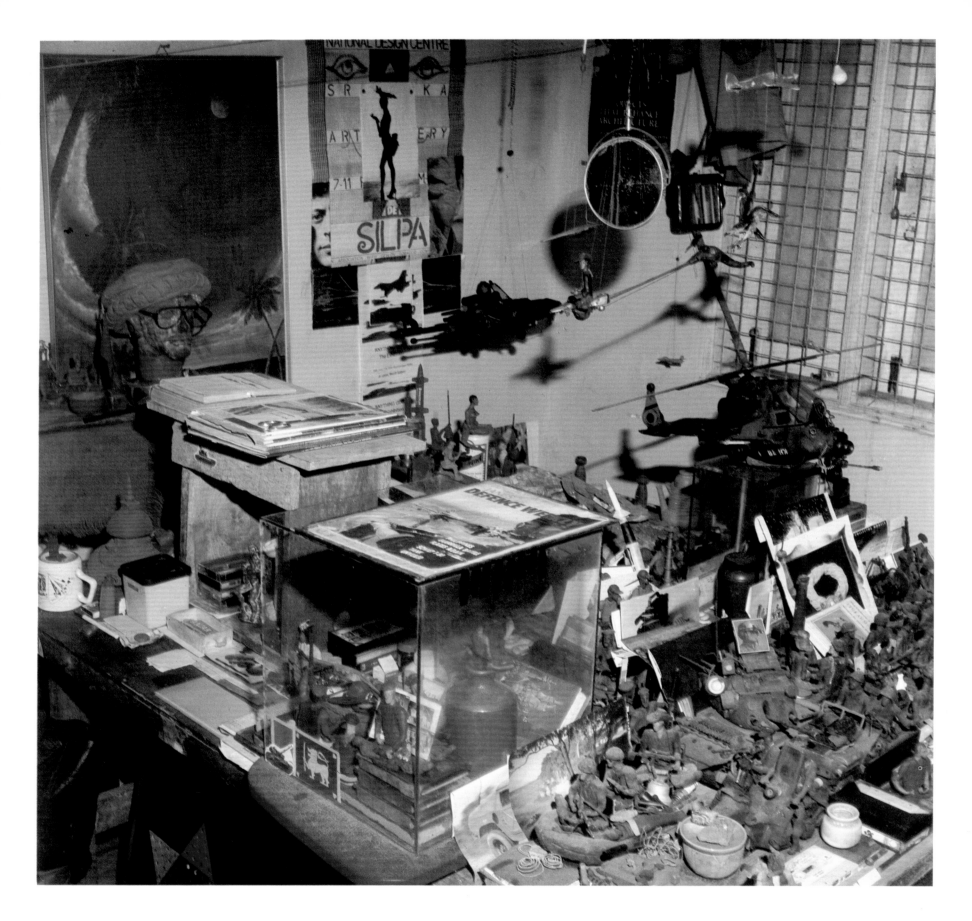

60   Tissa's plasticine models and Tissa's head cast, Colombo.

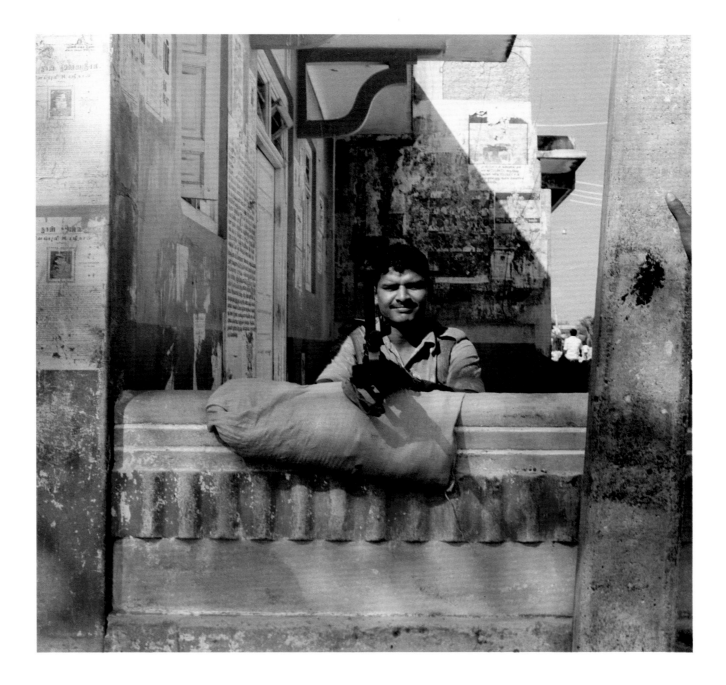

Indian soldier, Valvedditturai.  61

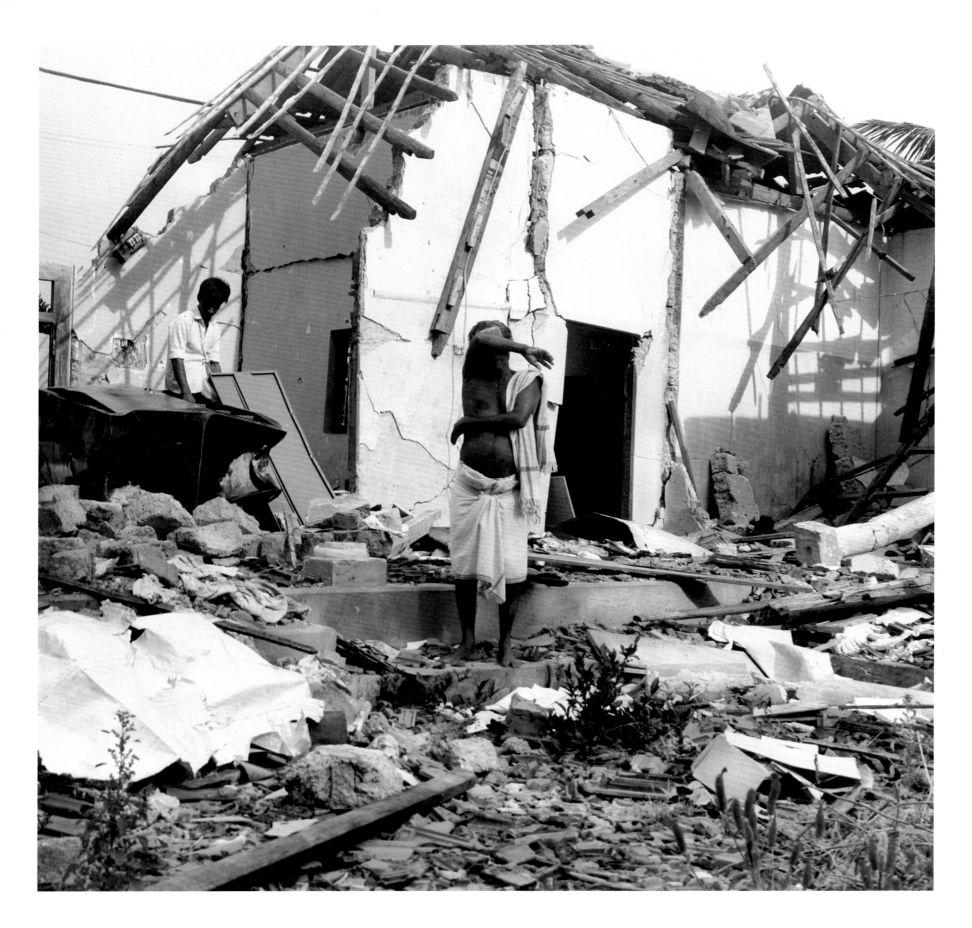

62   Broken, Urumppirai.

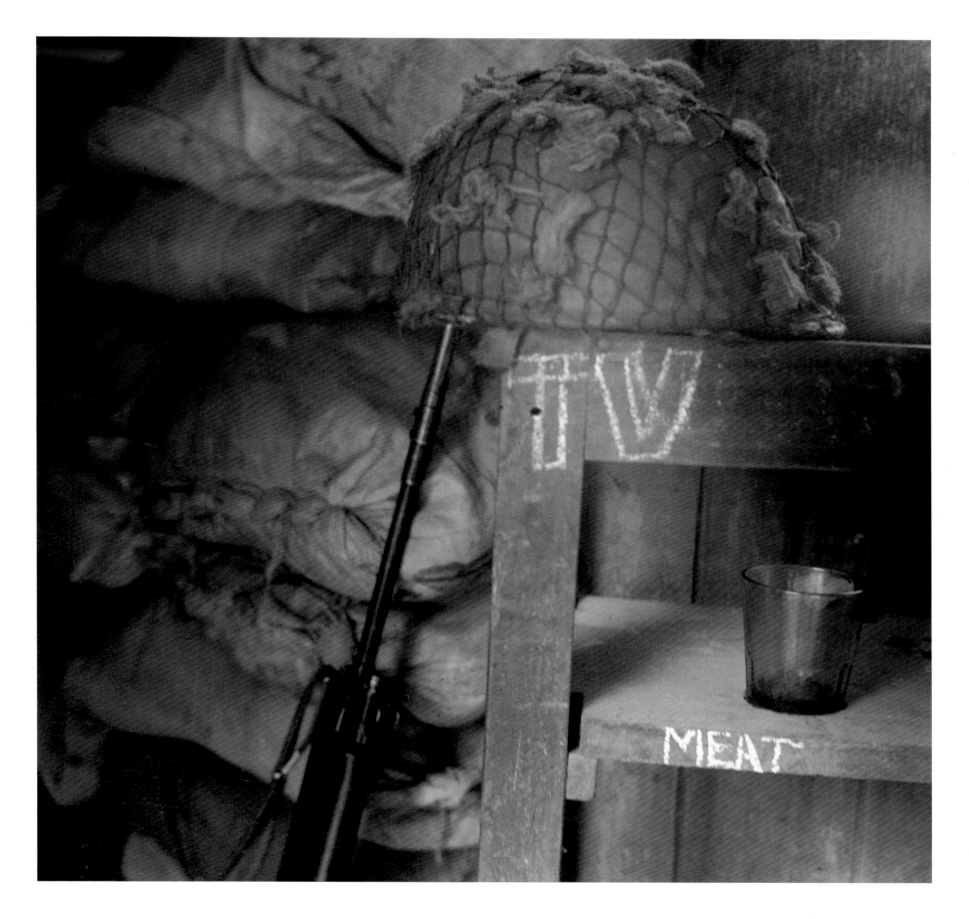

T.V. meat. An army bunker, Urumppirai.   63

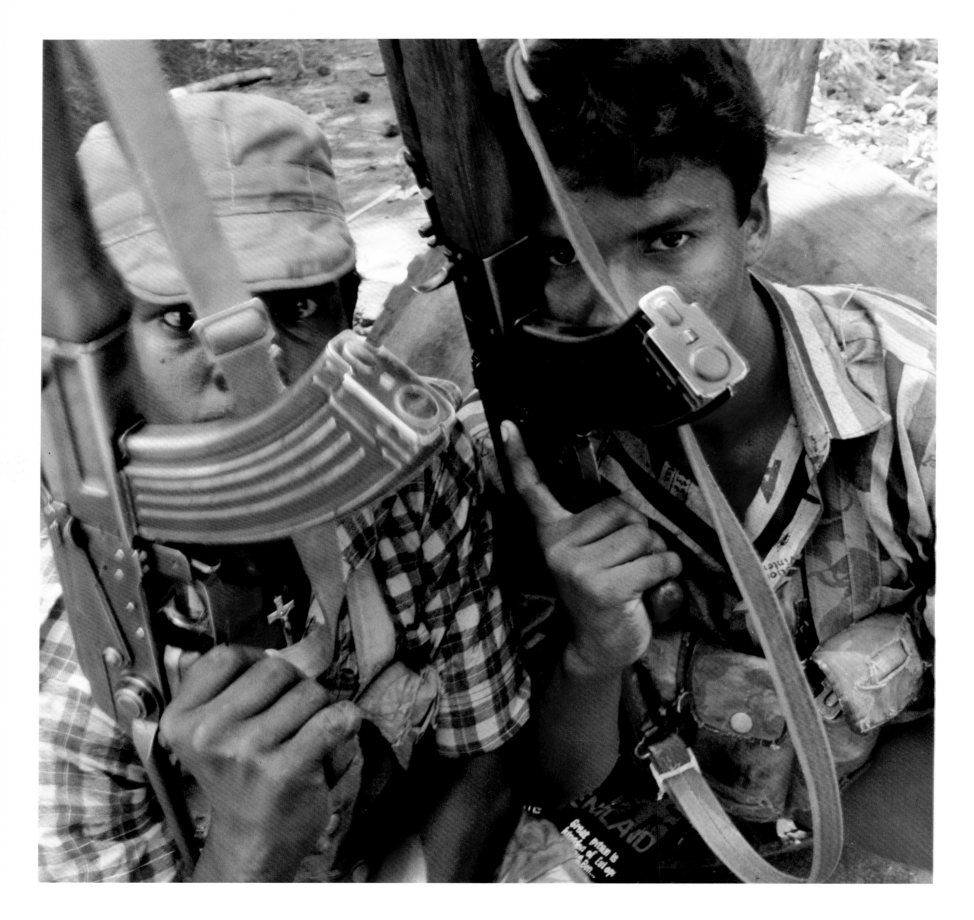

64   L.T.T.E. cadres, Vavuniya.

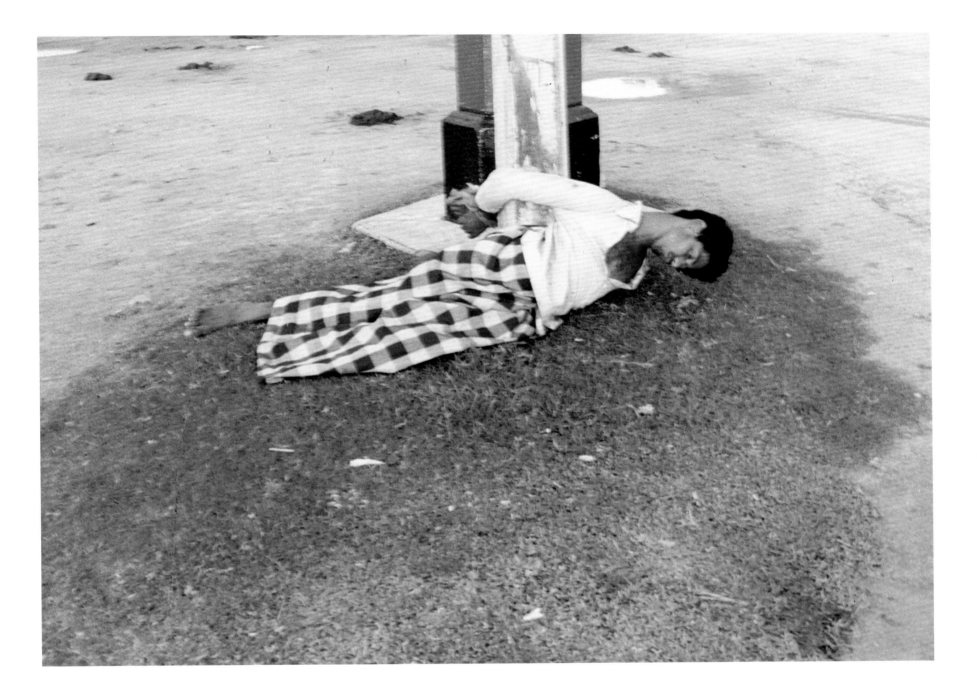

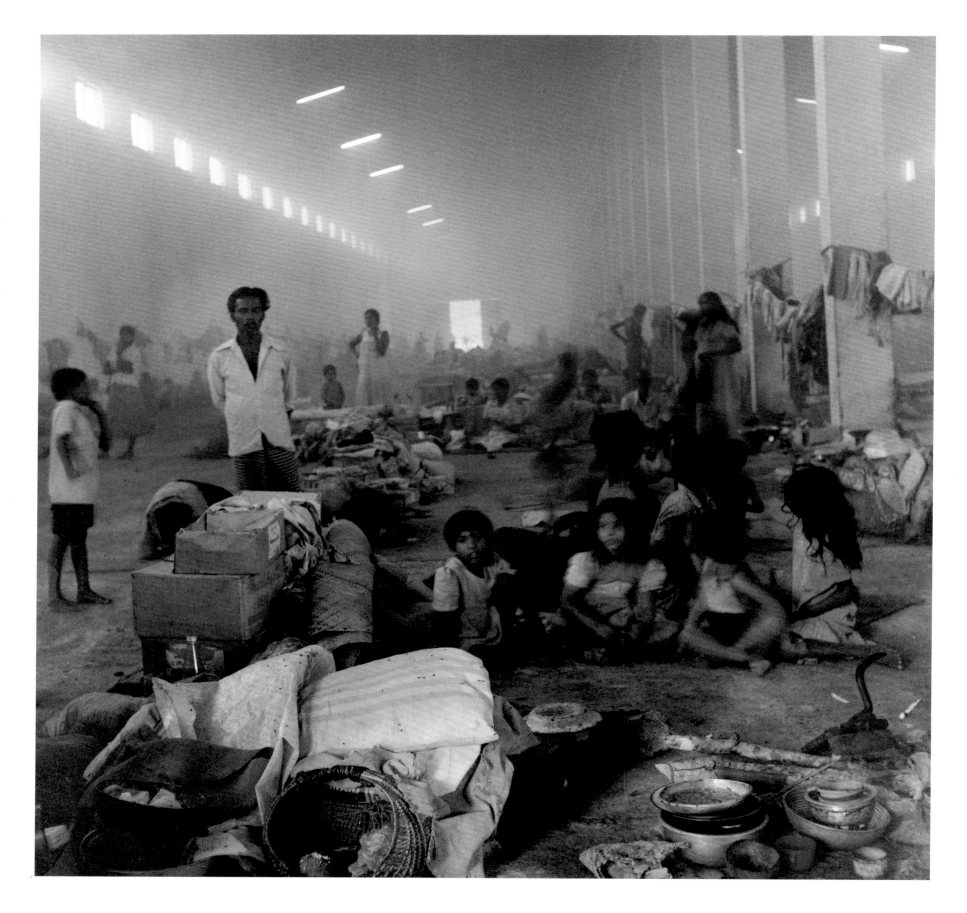

66   Clappenburg refugee camp, Trincomalee.

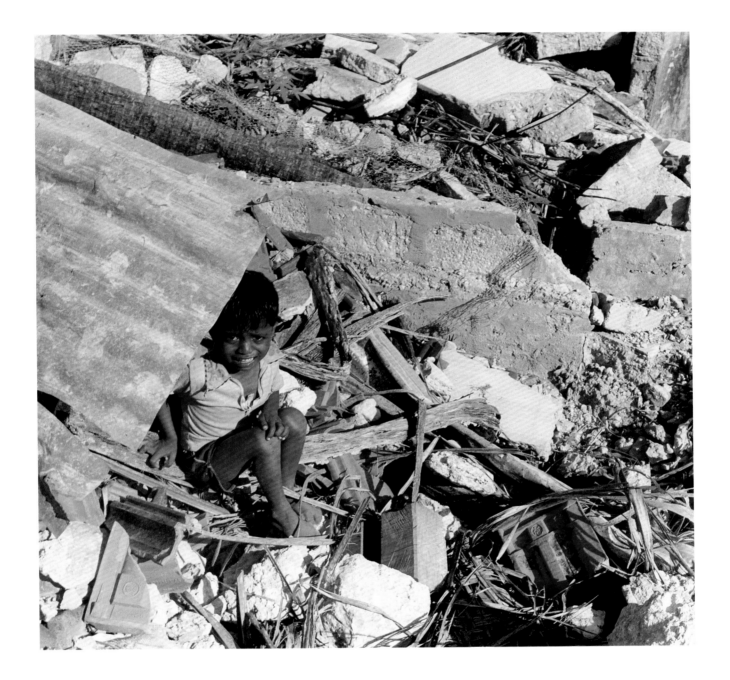

A child surrounded by house rubble, Valvedditturai.   67

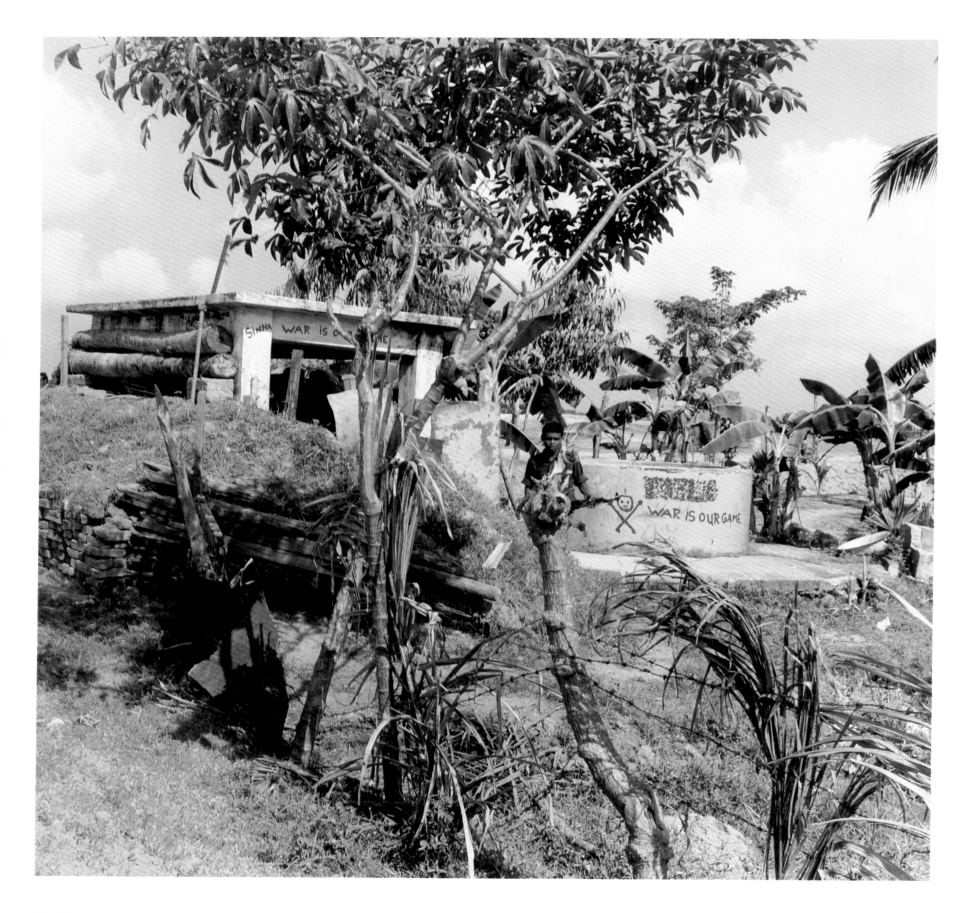

68   War is our game, army camp, Eastern Province.

Shop full of corpses, Batticaloa.  69

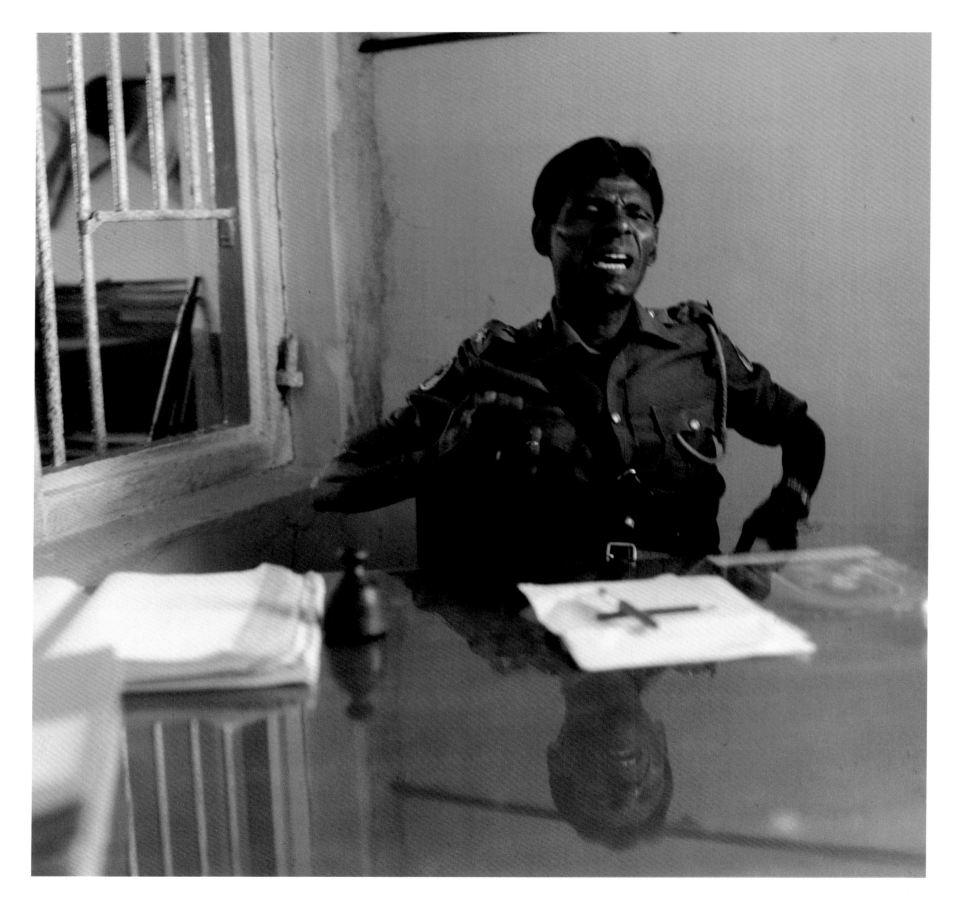

70   Security desk, Hambantota.

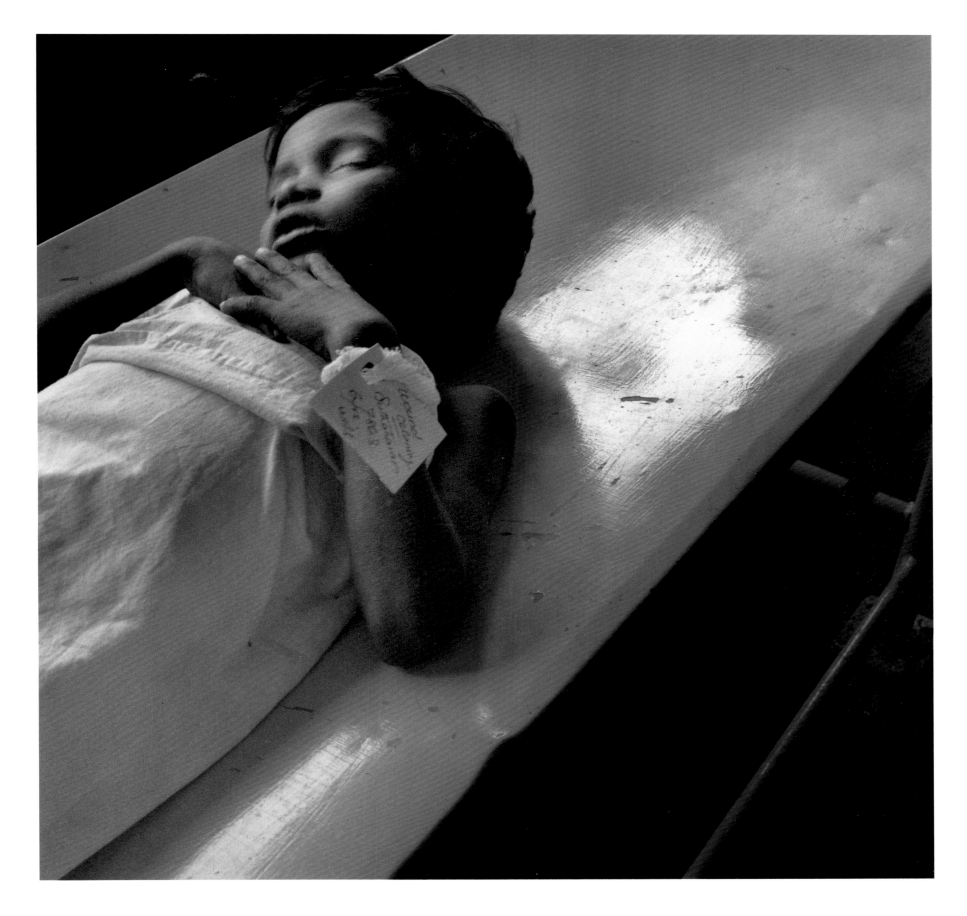

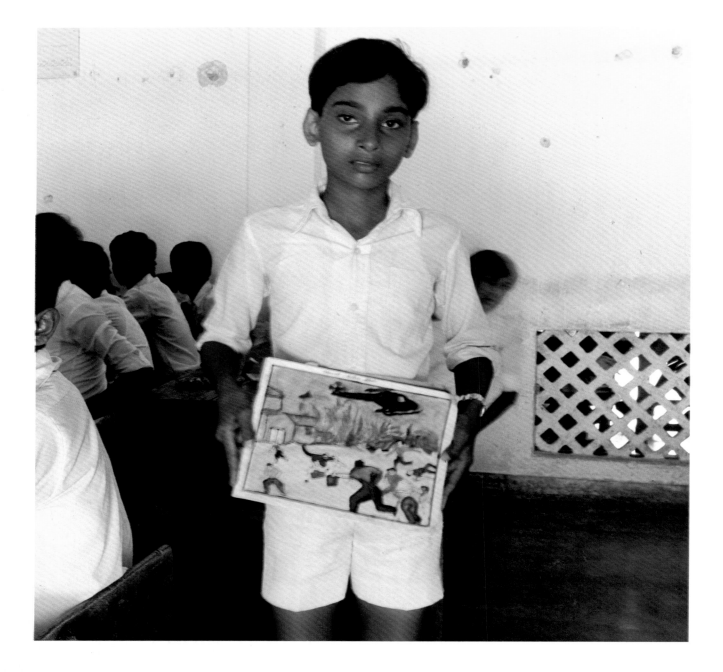

72   Boy with his drawing, Jaffna.

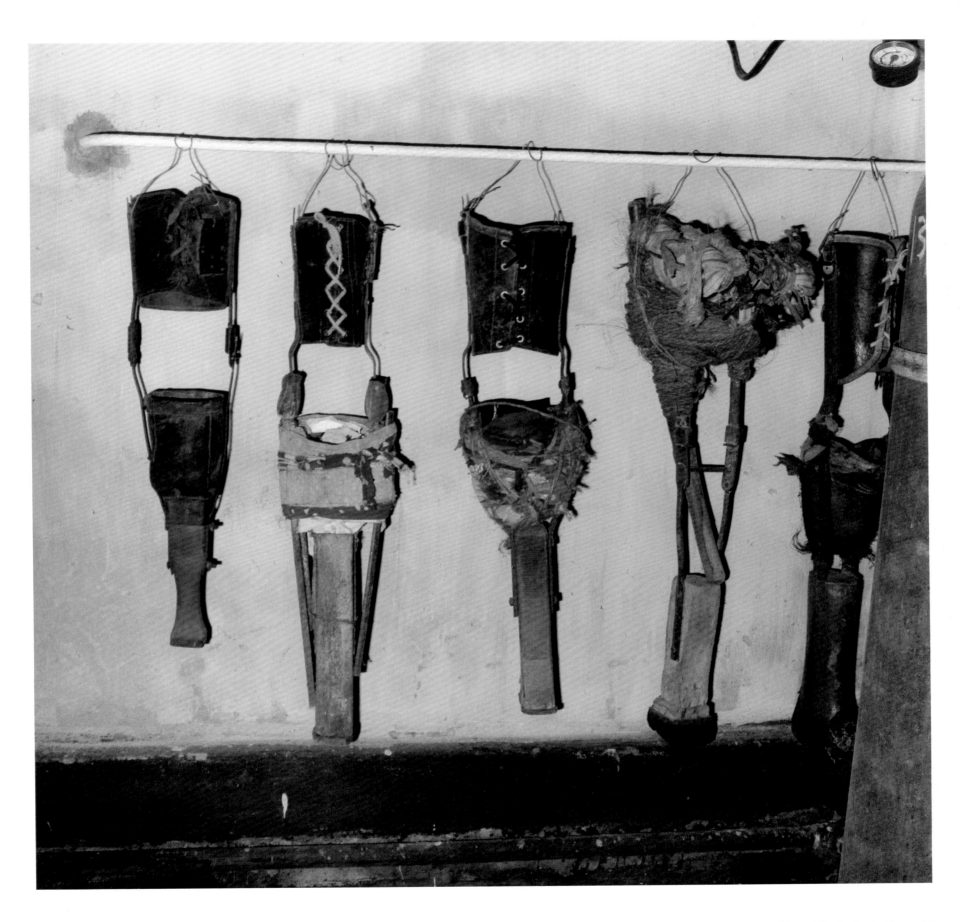

Makeshift limbs, Jaffna. 73

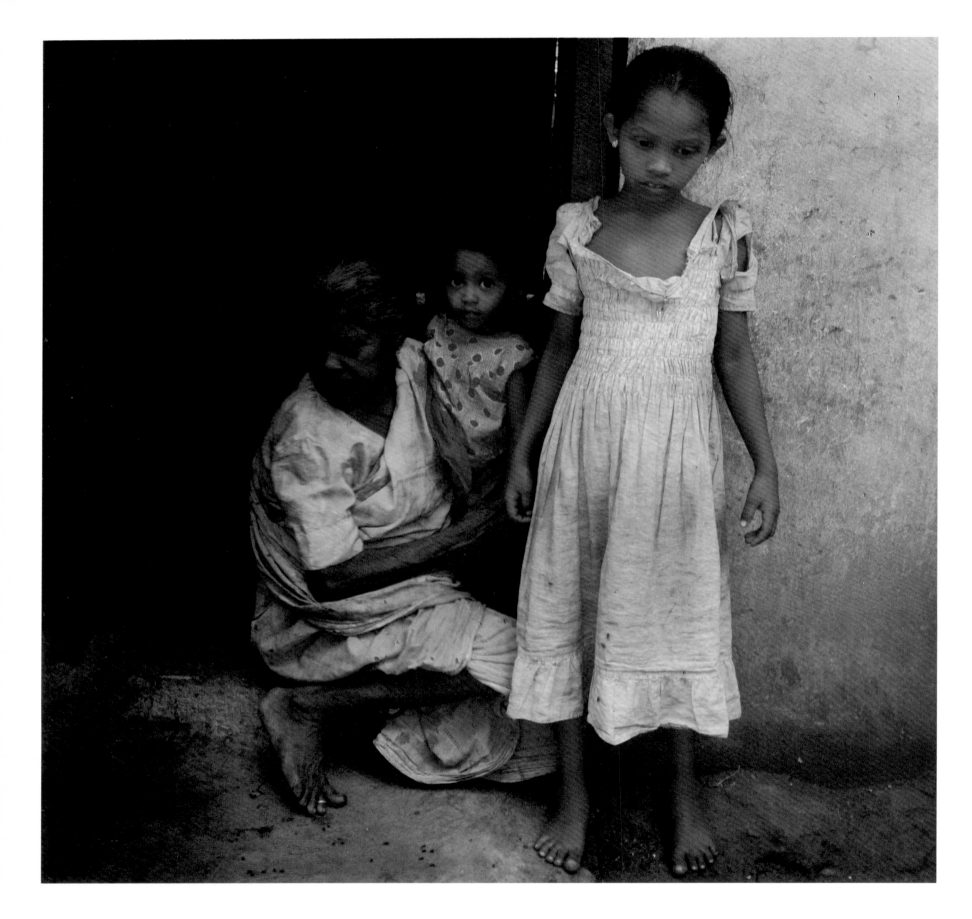

74   Family, Colombo.

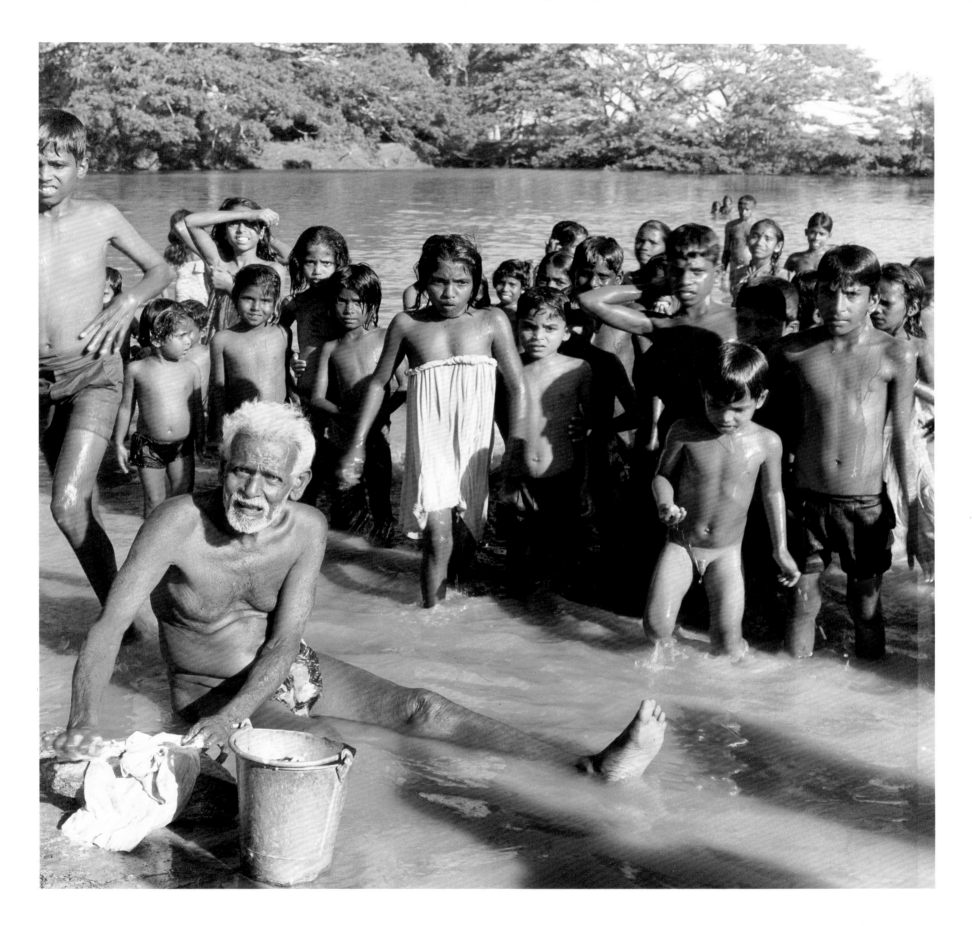

Refugees bathing, Madhu.   75

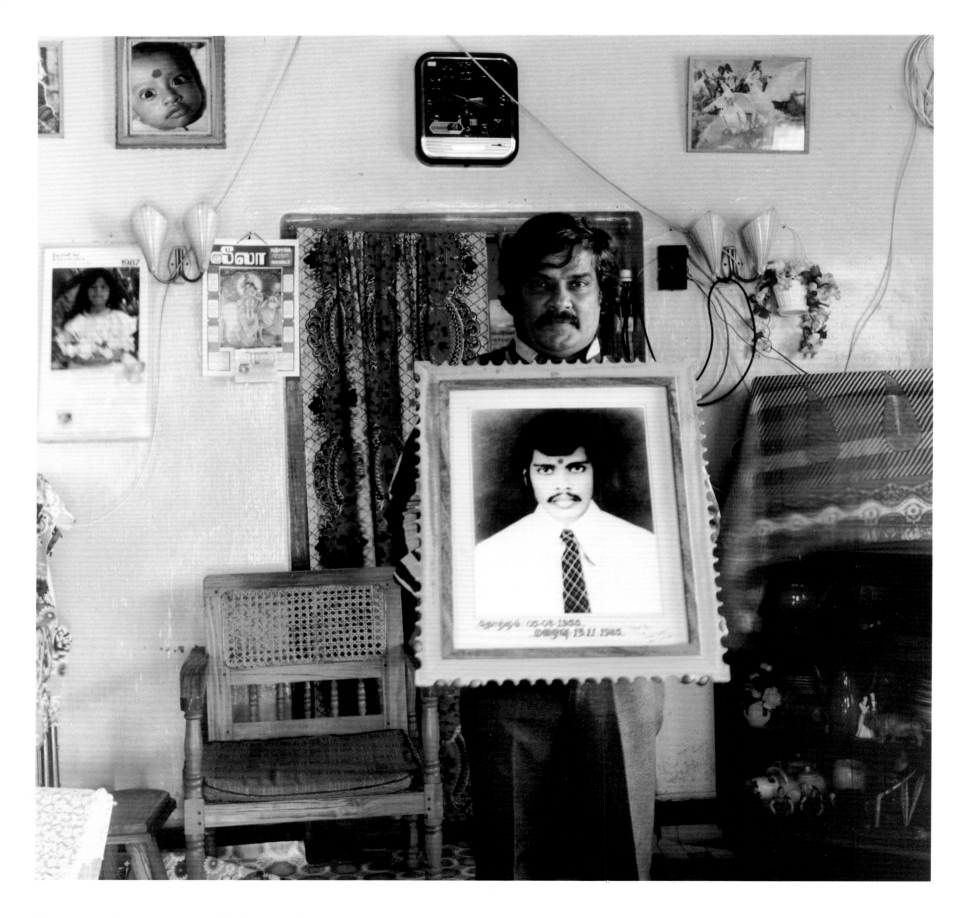

76 A man with a photograph of his dead son, Batticaloa.

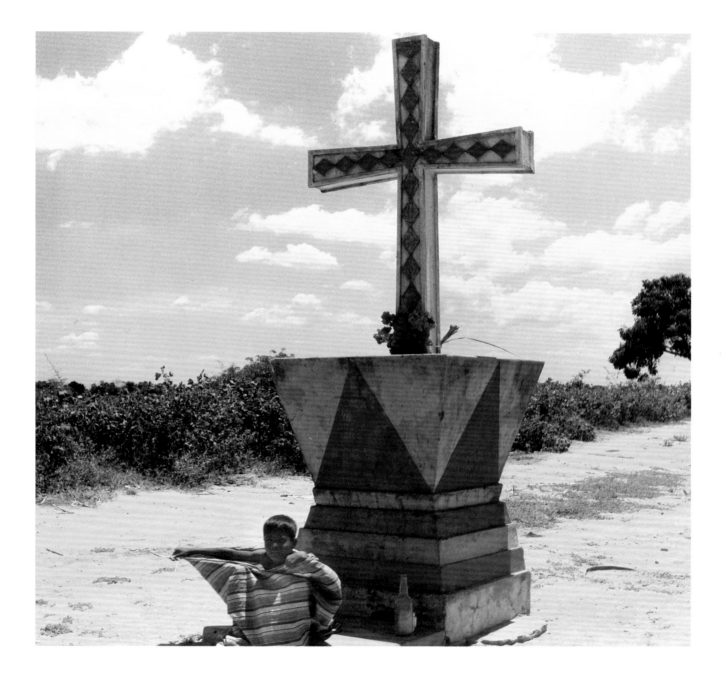

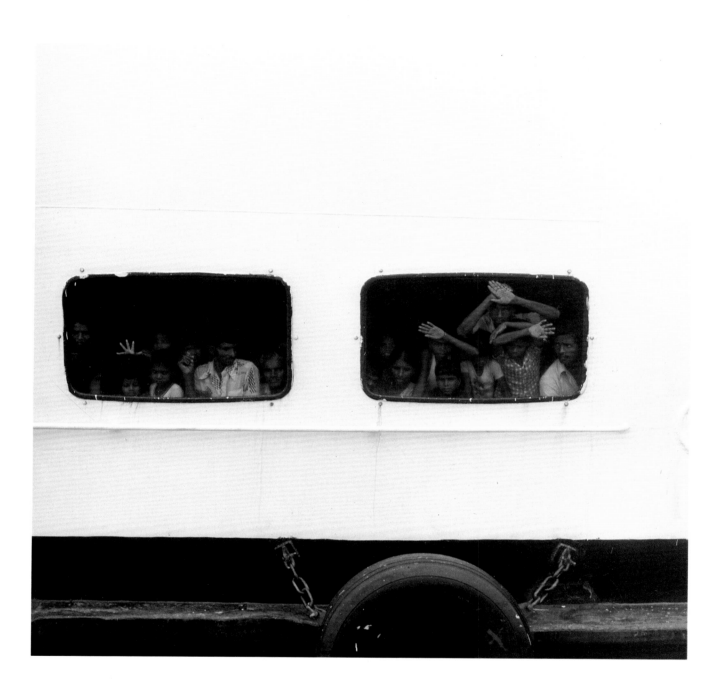

78  Refugees returning from India to Tallaimannar.

# THE WAR OF TEMPTATION

The Messenger of Death and
Mara, Chief of Demons and enemy of Buddha.

## An Adolescence in the Brutality of War

*In the distance earthy sound and bomb alert. You could tell the army mortar, you could tell the Tigers' mortar. Their sounds had a different pitch. In between; still sweet bird song and voices coming closer. The voices became lighter and bird song ceased. Now much closer and then all around us. And people huddled together under whatever shelter, eyes tight shut at each blast. And then bodies, mutilated, torn apart. And wailing mothers and desperate angry fathers and children no longer smiling, tears streaming, and new babies born with clenched fists. And then a lull. A brief retraction from violence. A chance to rearrange and repair. A chance of a smile. Tender caring. And then again fearful. More bombs and carnage and lifeless inaccurate reports in the press.*

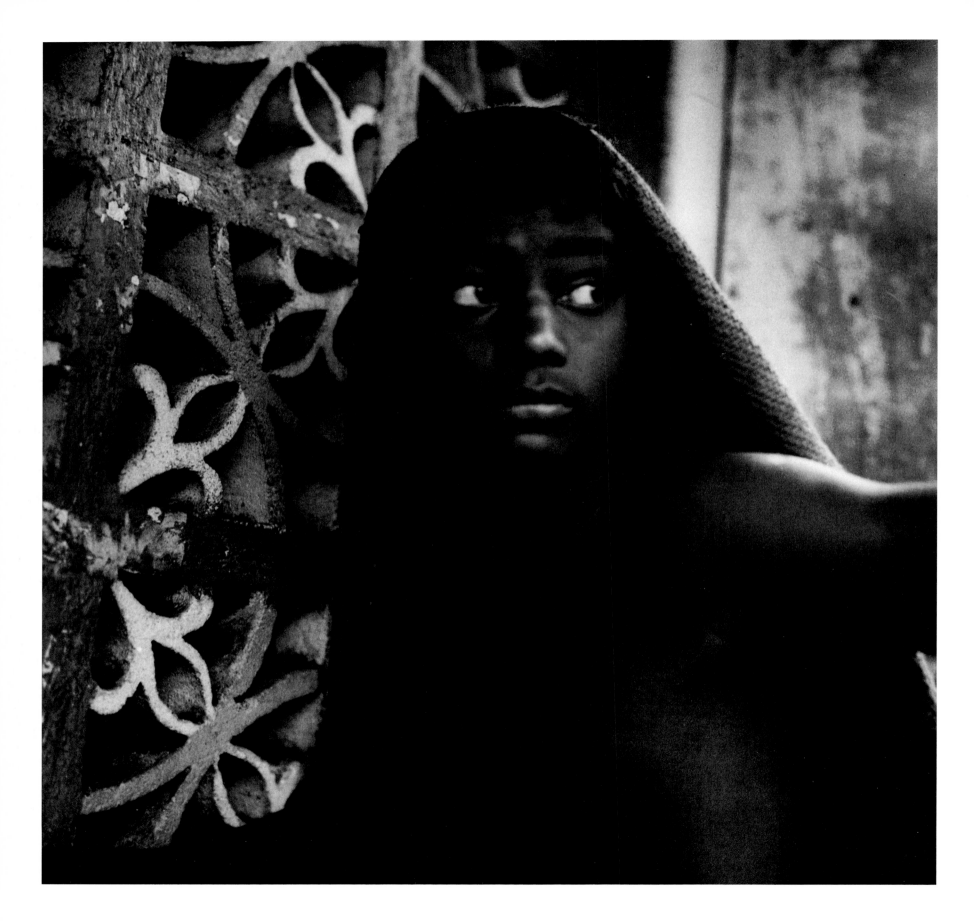

80   Labourer, Hakmana.

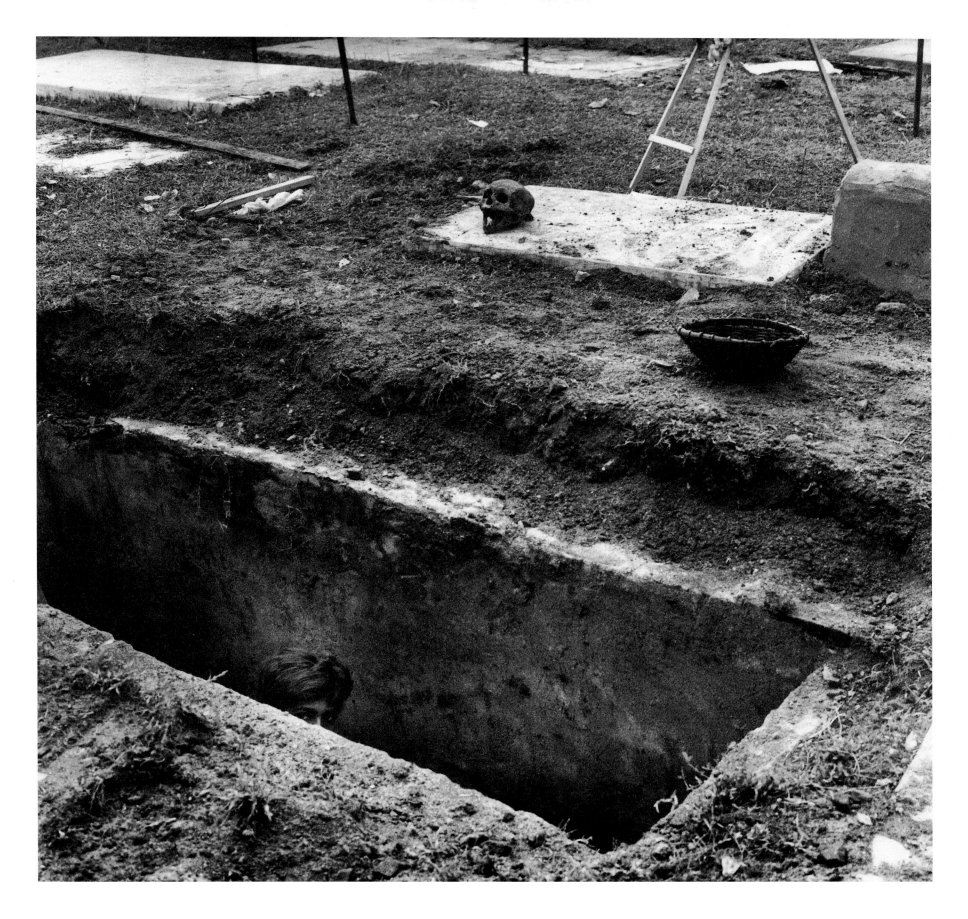

Grave digging, Dikwella. 81

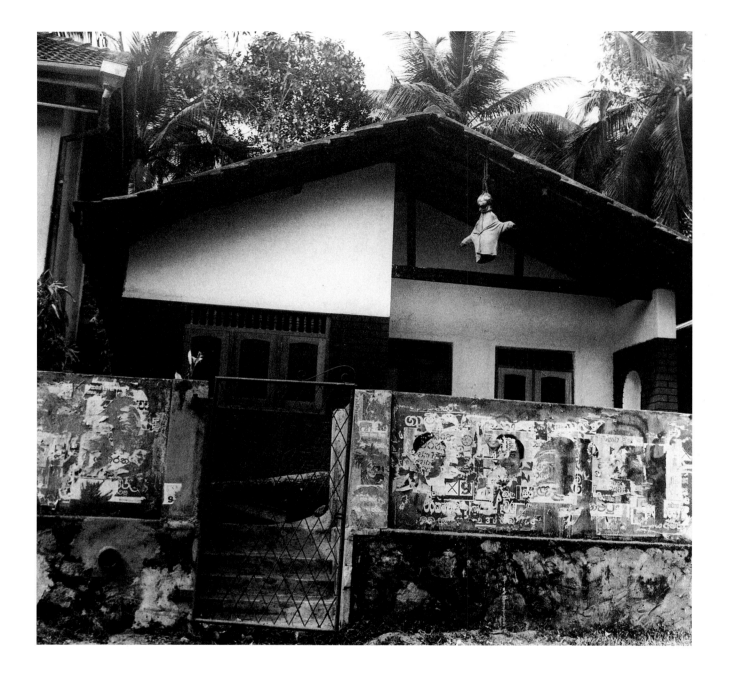

82 Hanging effigy, Beliatta.

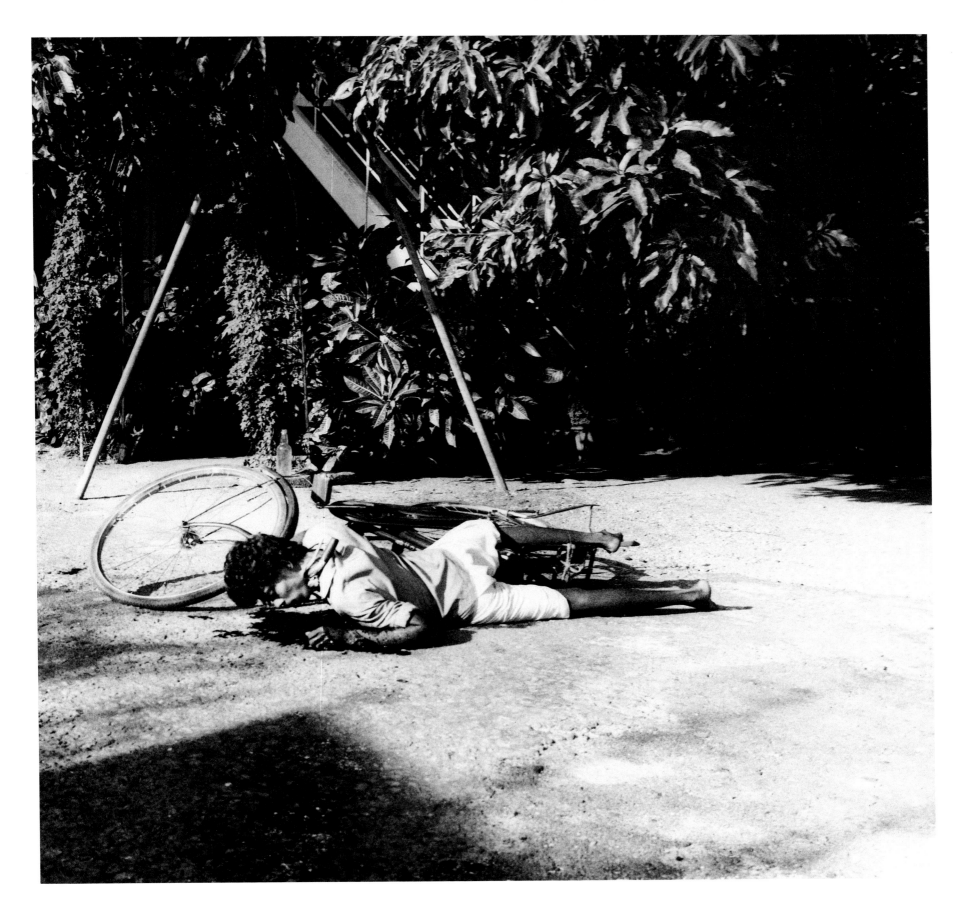

Execution, polling day, Tissamaharama.  83

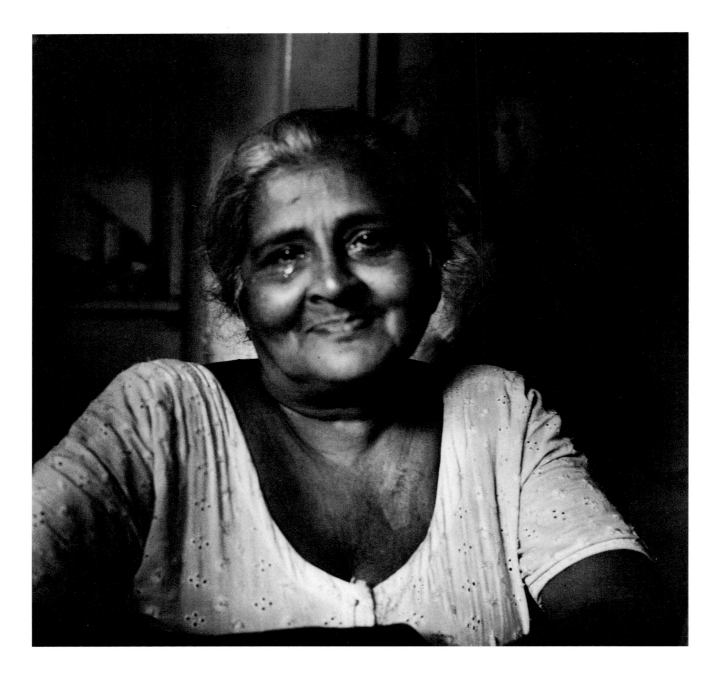

84   A woman's agony, Tissamaharama.

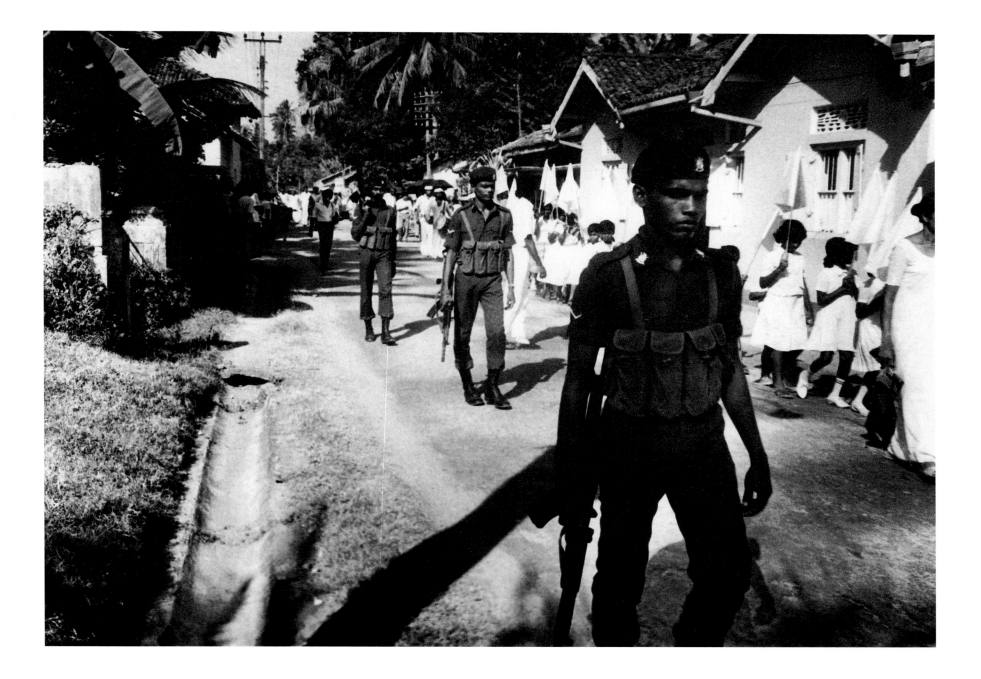

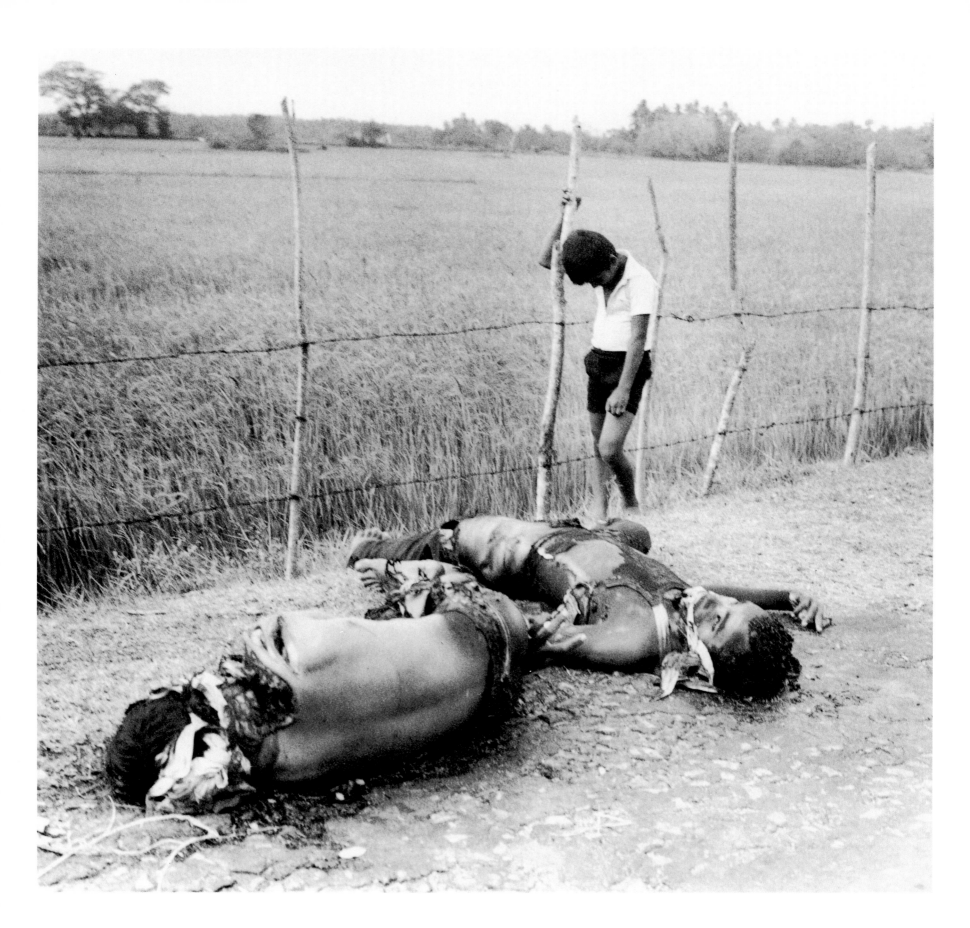

86   Corpses, Tangalla.

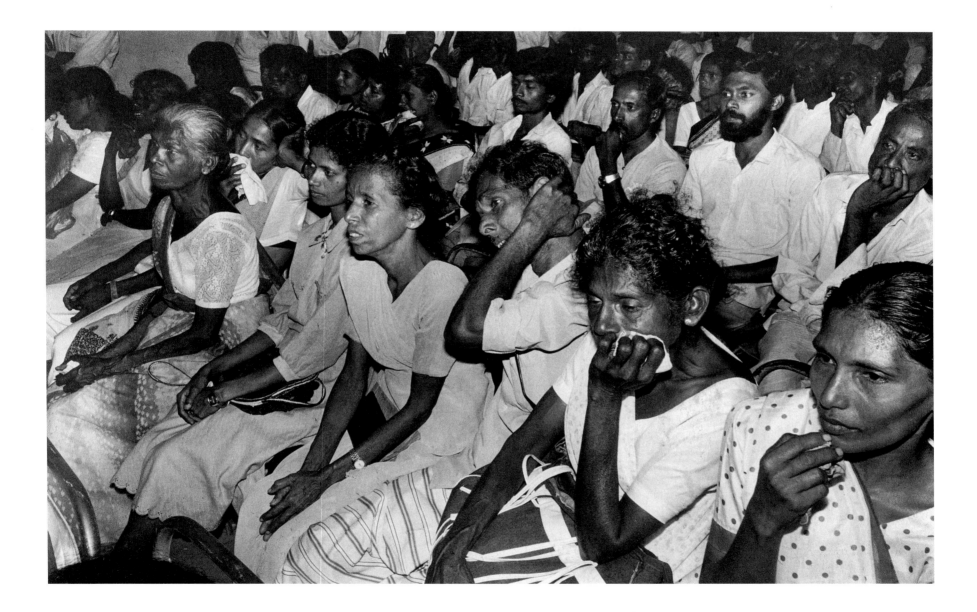

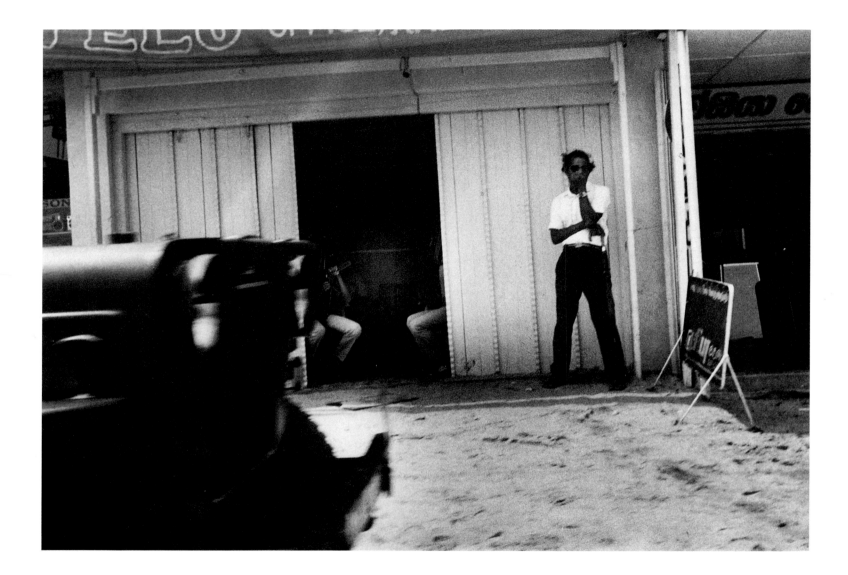

88  Wild West in the East, Kalmunai.

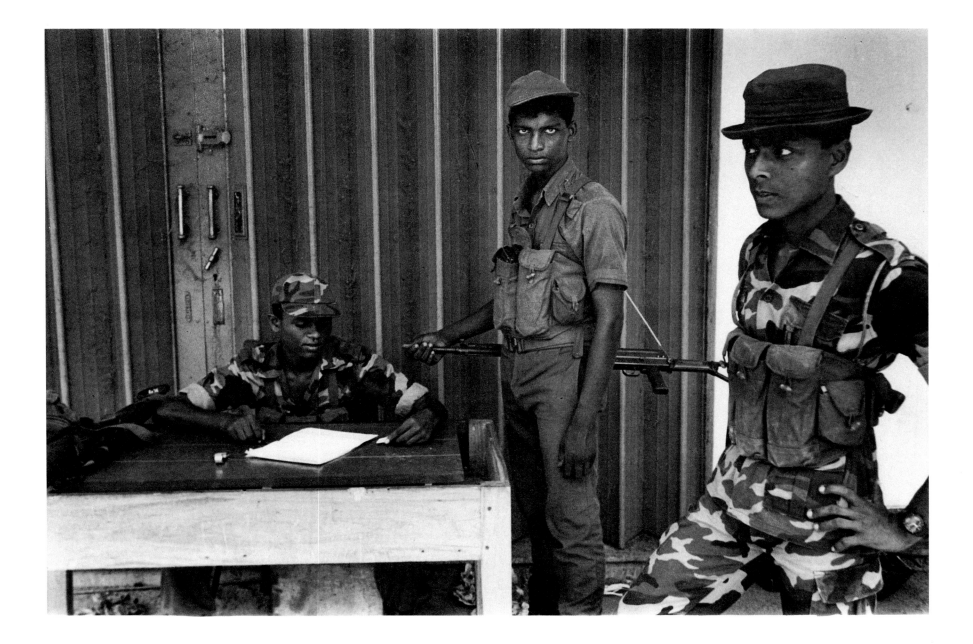

Young soldiers, Eravur.   89

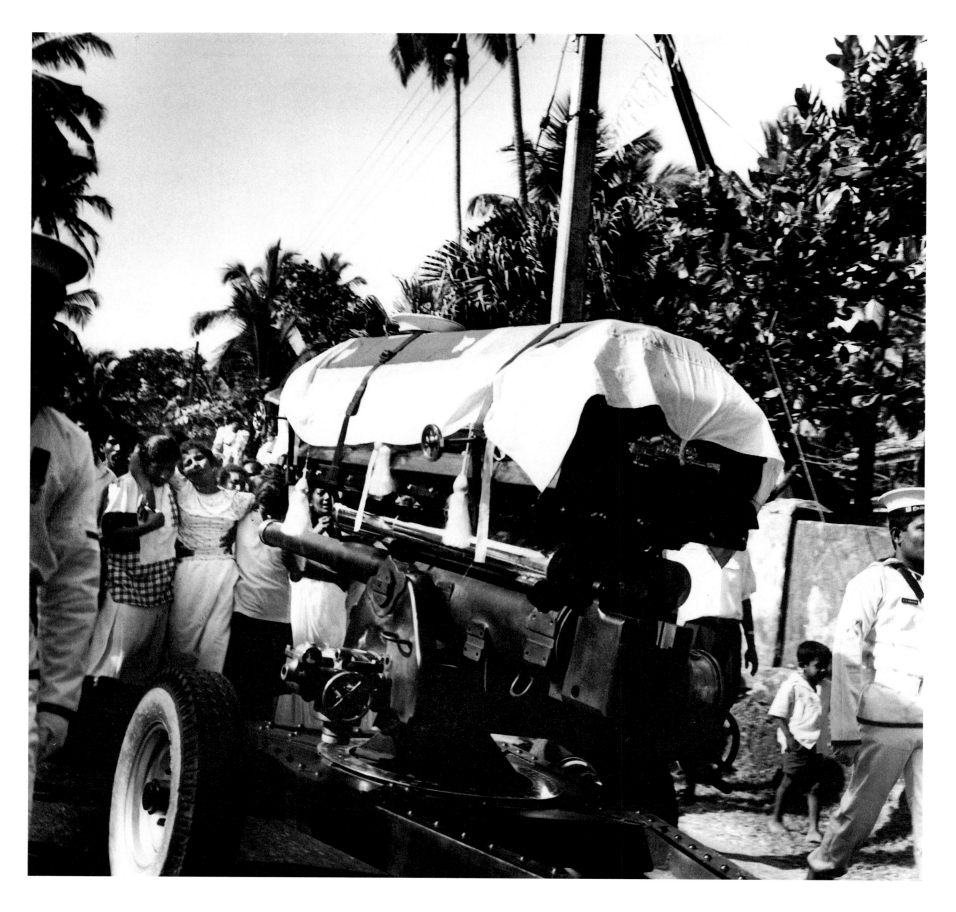

90　Navy funeral, Galle.

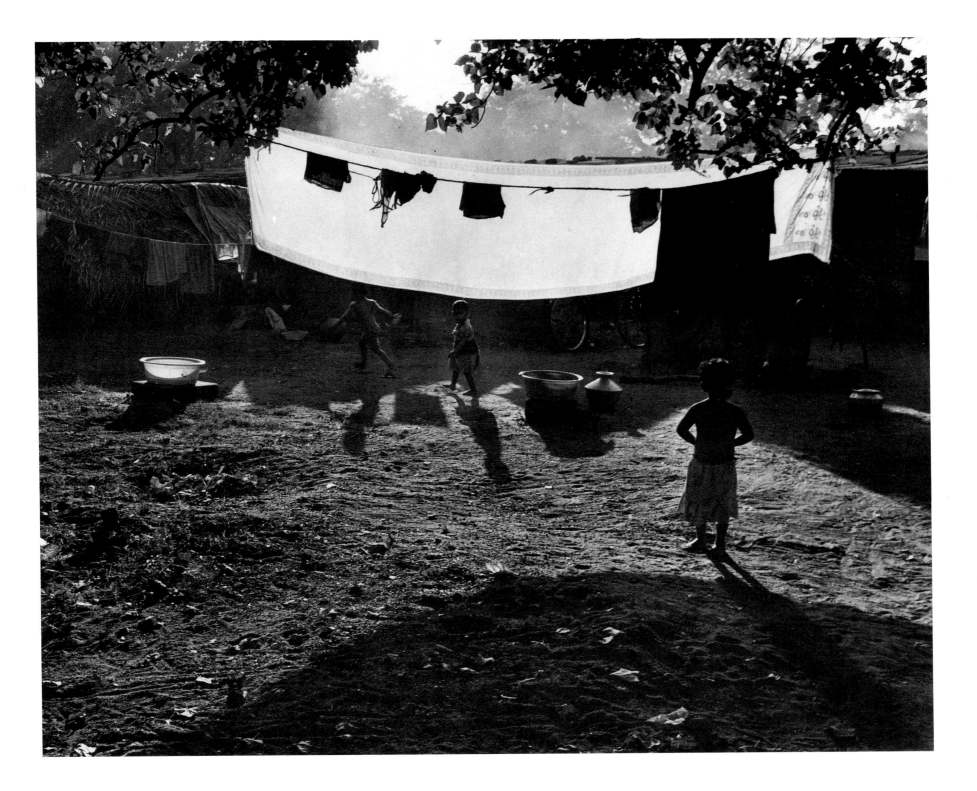

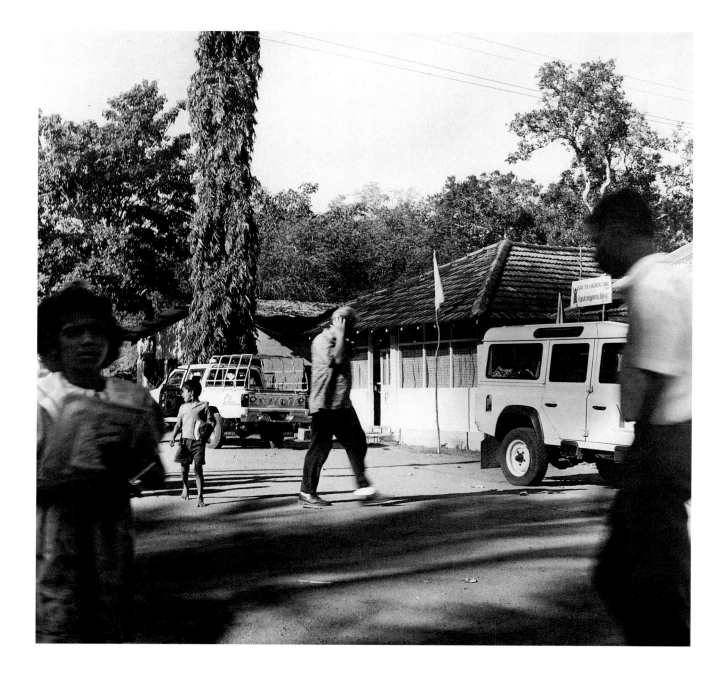

92   Aid worker, Madhu refugee camp.

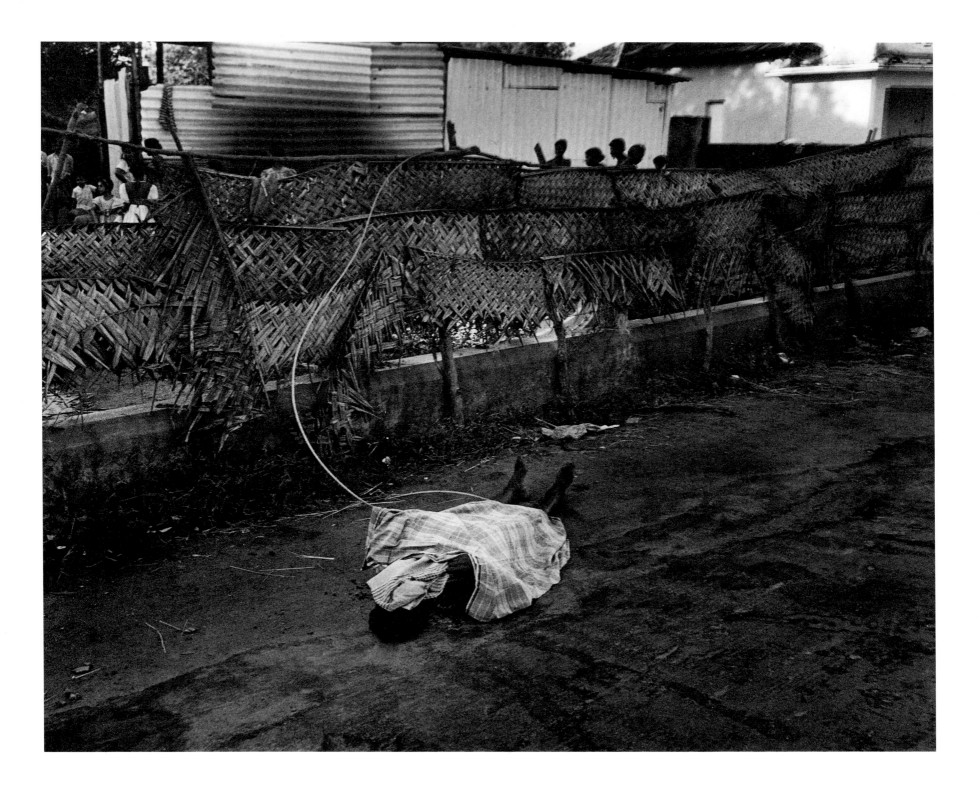

A corpse lies outside a refugee camp. A power cable connected to the back of his neck has left a large charred hole in its place, Batticaloa.   93

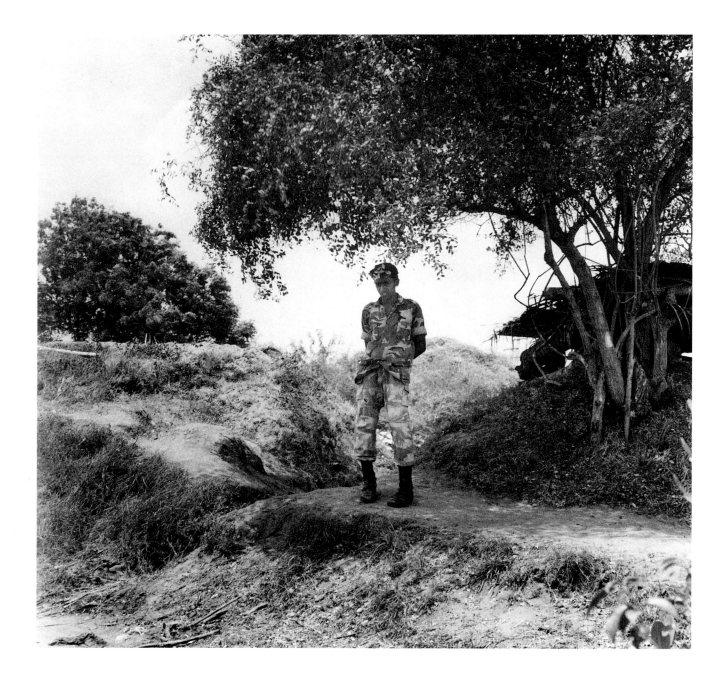

94 A young soldier at the battlefront, Tiriyai.

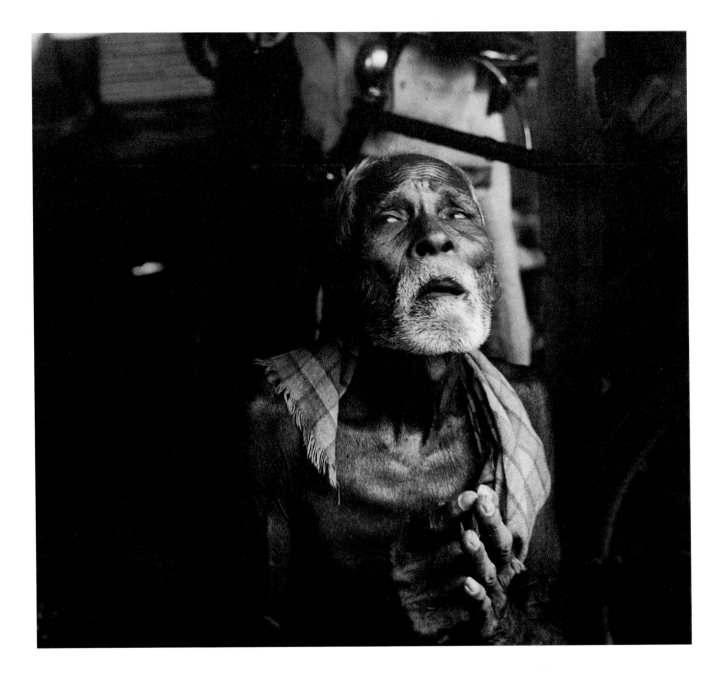

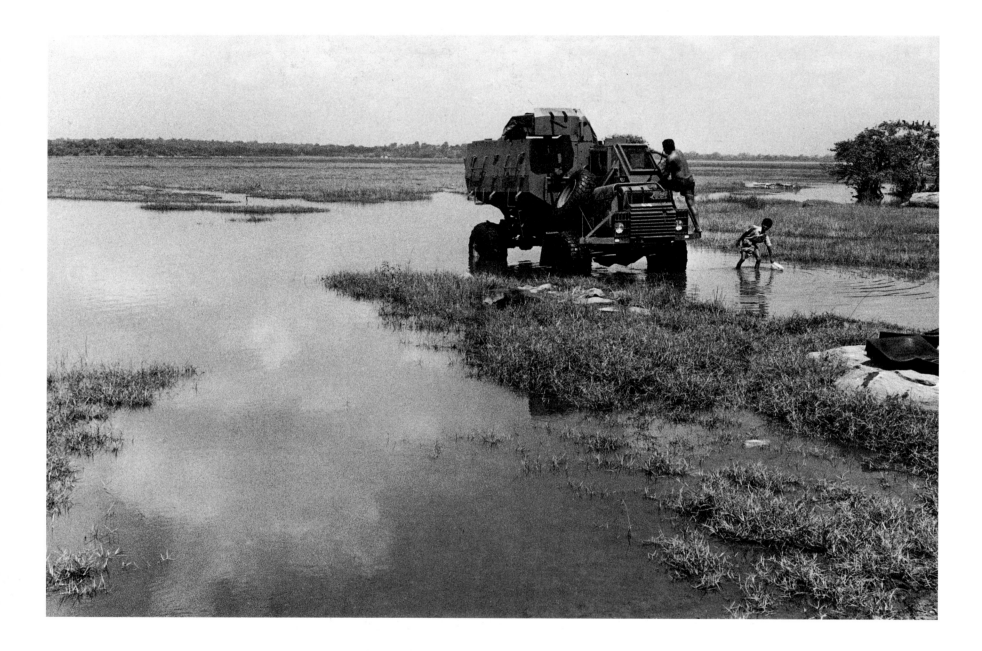

96   Bathing an army Buffalo tank, Arugam Bay.

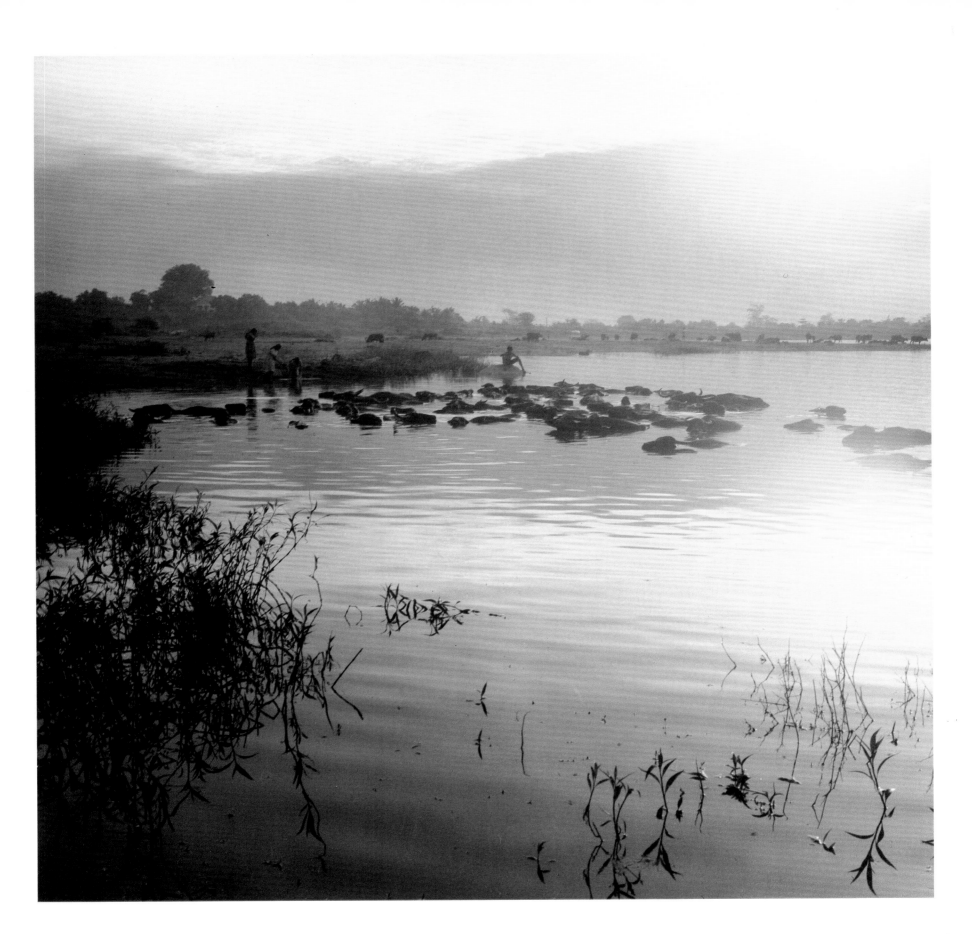

Bathing with buffalo in the tank (reservoir) at Embilipitiya.   97

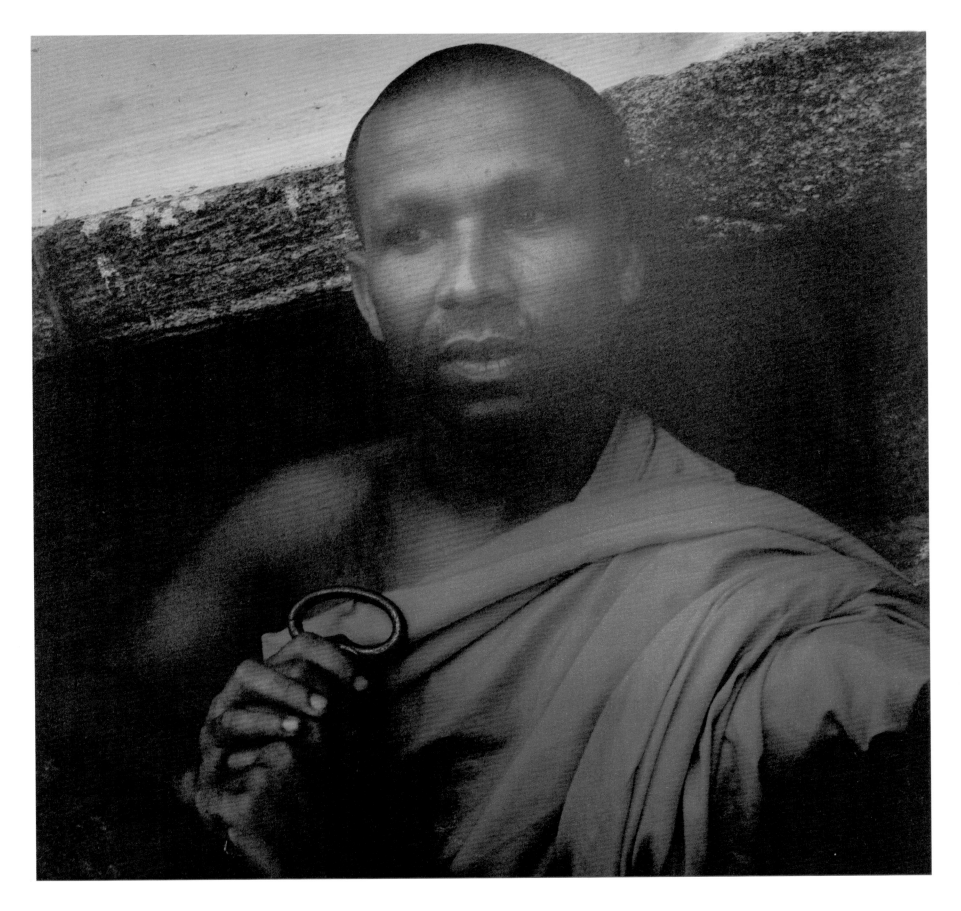

Buddhist monk, Lankatilaka Temple. 99

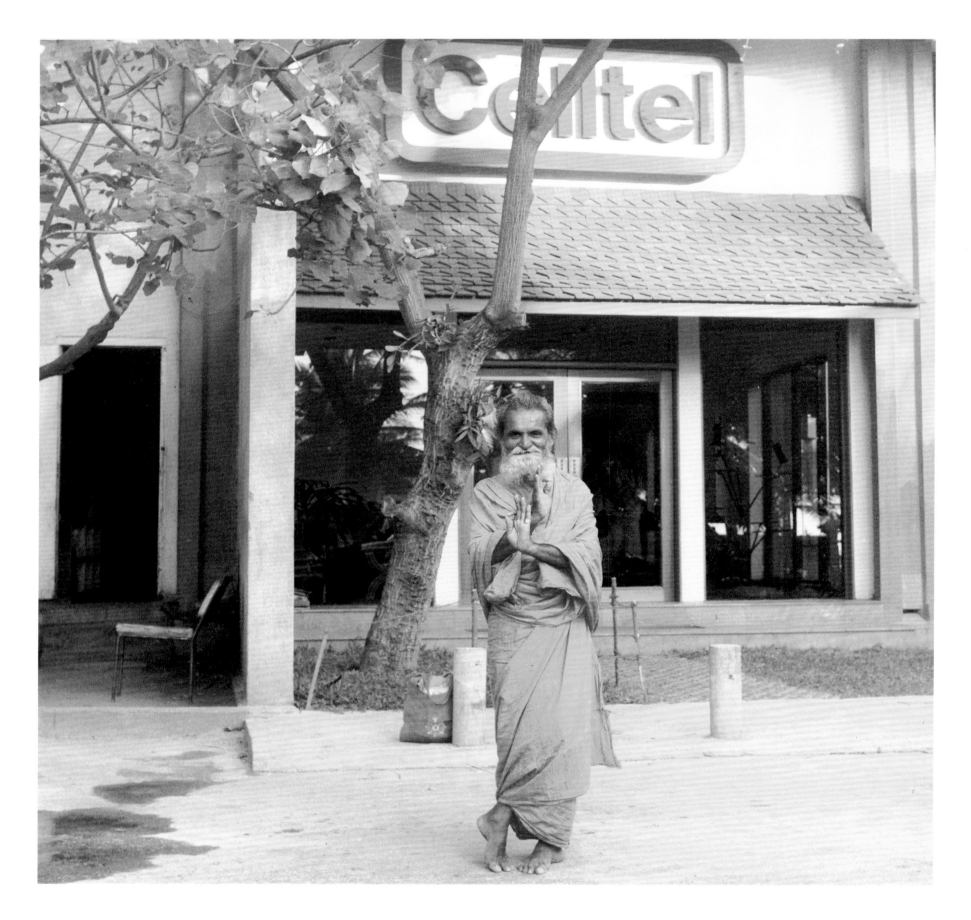

100  Swami communications, Colombo.

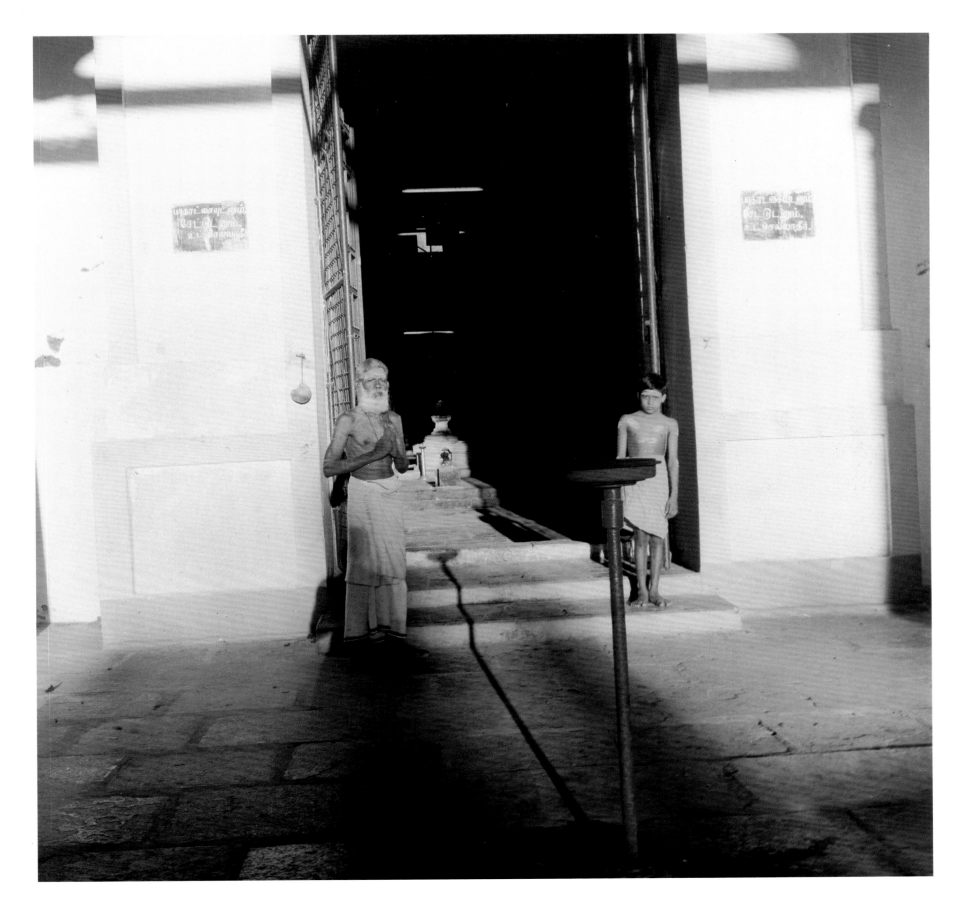

Hindu kovil, Jaffna. 101

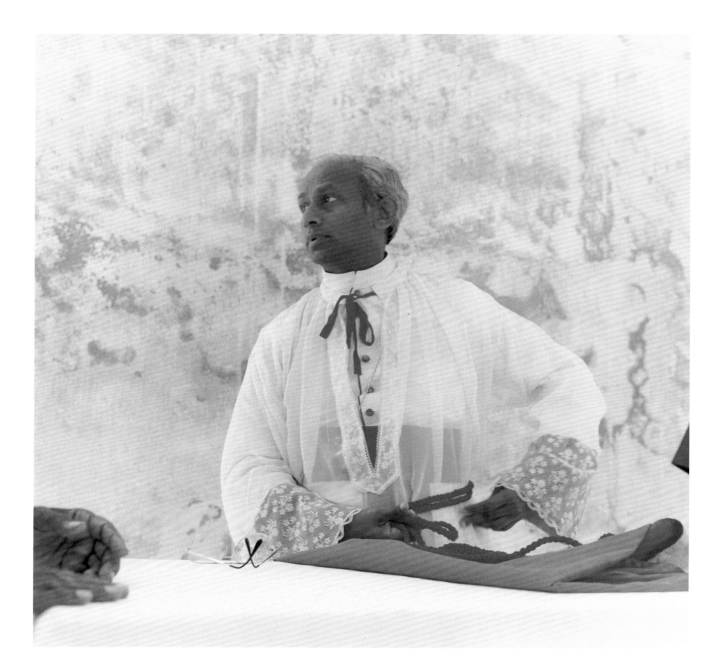

102 Bishop of Batticaloa.

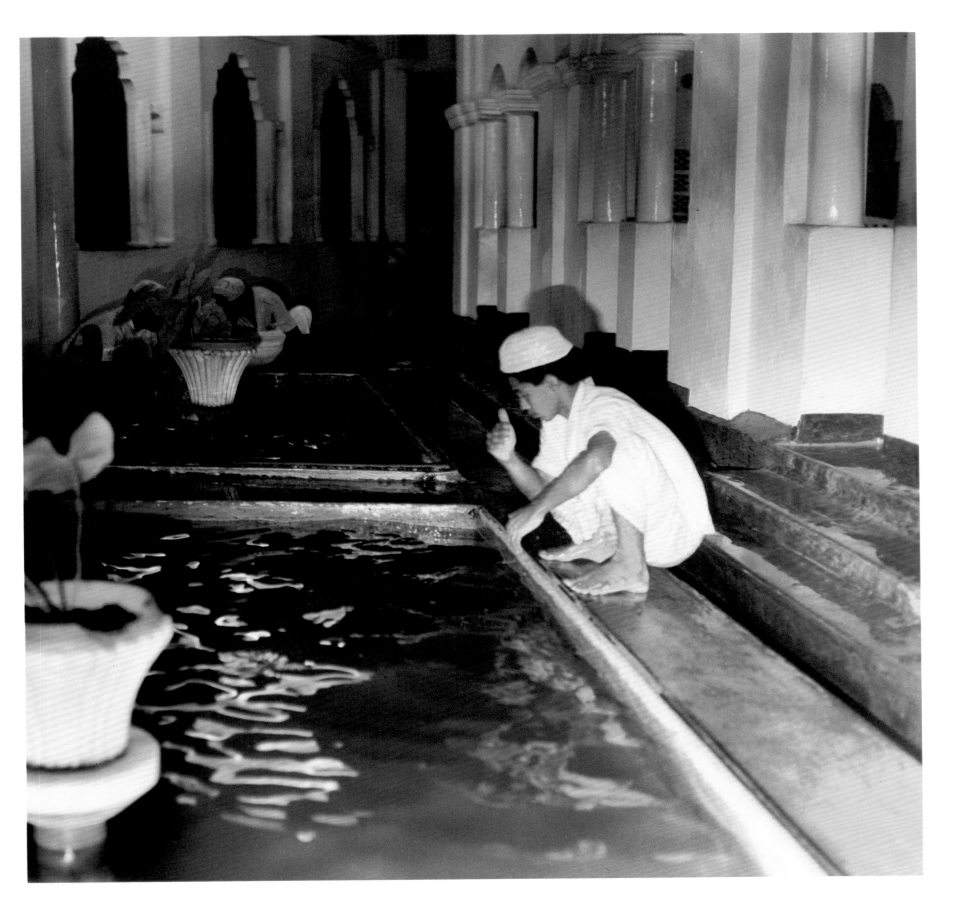

Muslim boy at Mosque, Hambantota. 103

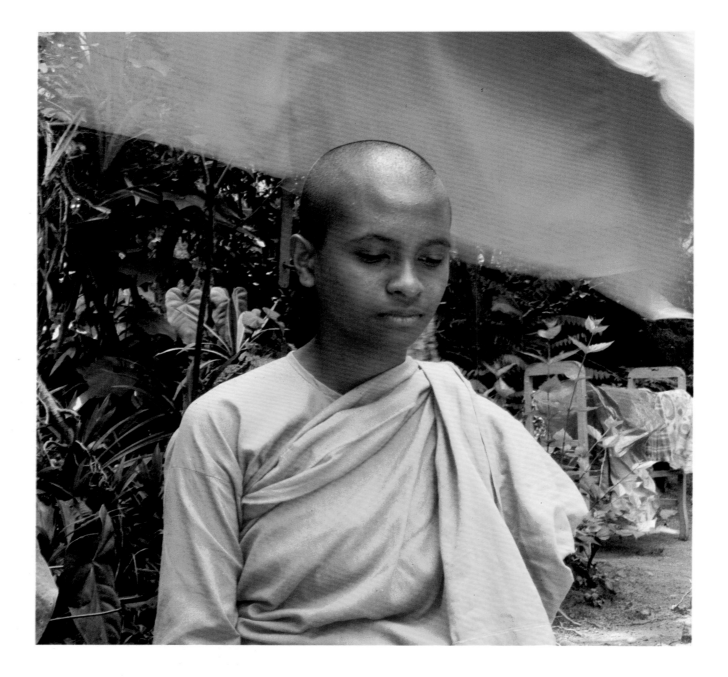

104  Buddhist nun, Kandy.

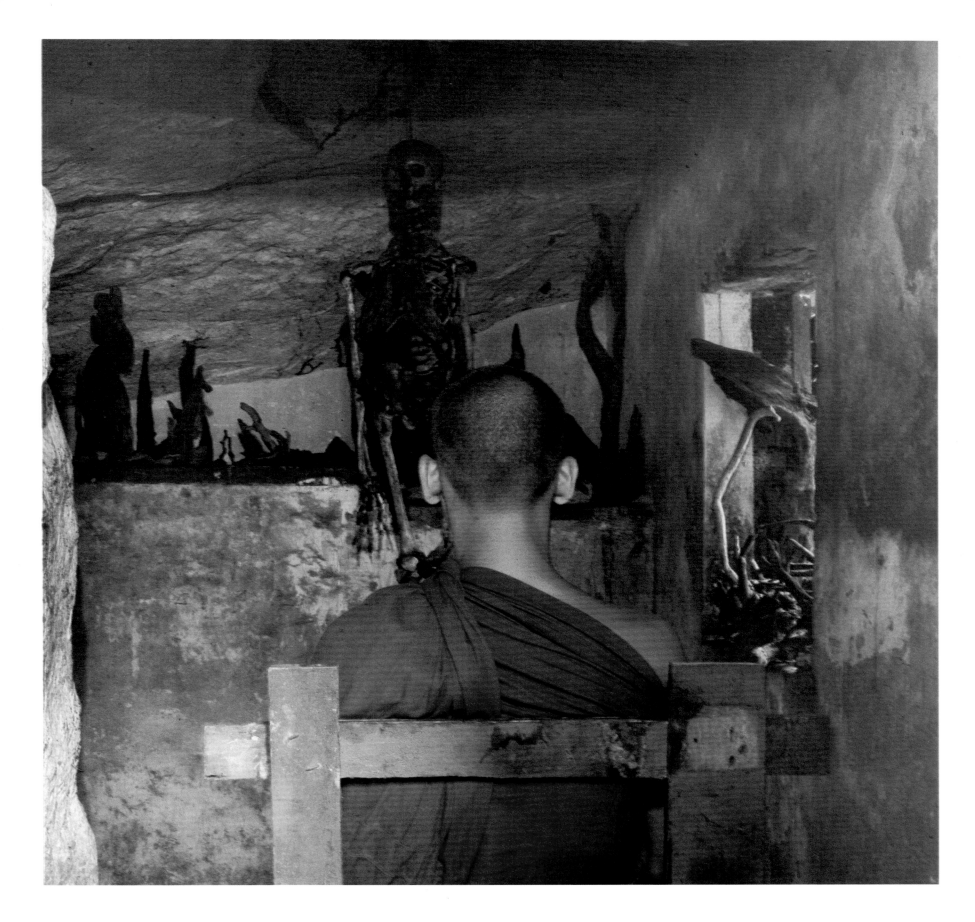

A hermit meditates in front of the old keeper of the temple, Ingiriya. 105

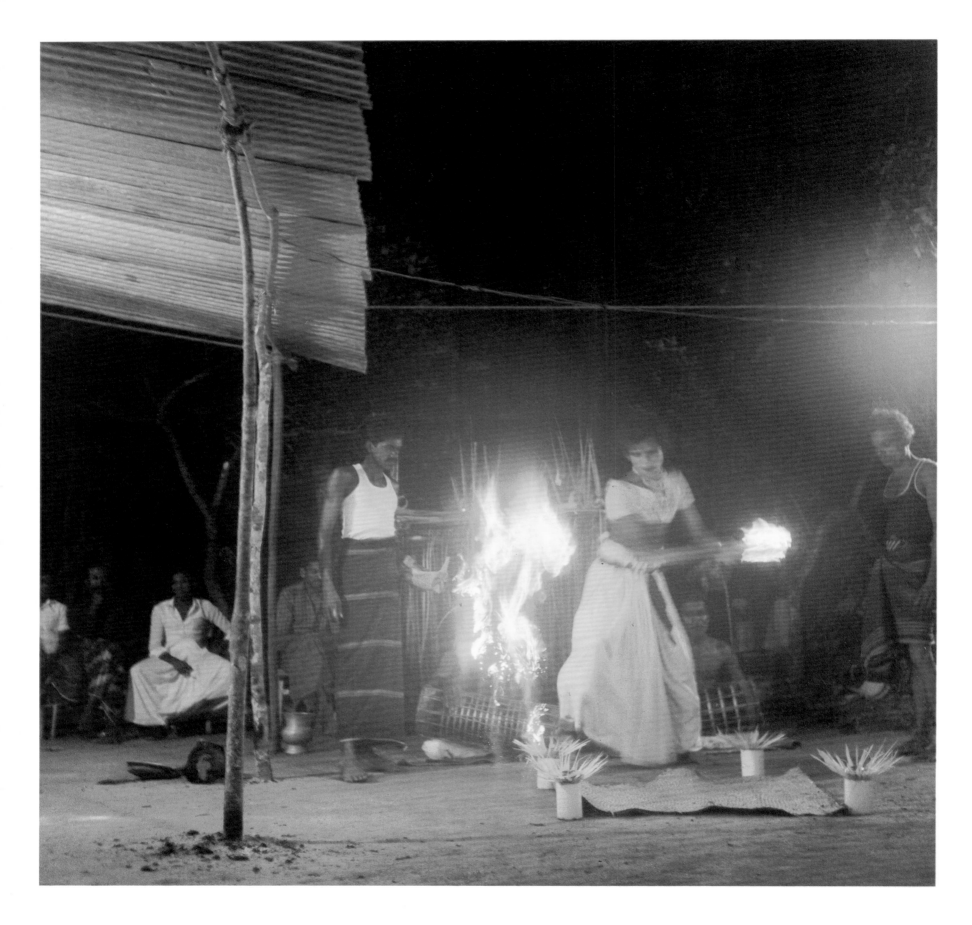

106 Exorcism, Weligama.

# THE MAKARA

The Makara represents the banner of Kama and is endowed with occult and magical powers, especially those relating to the fertility of rivers, lakes and the sea, identifying it with reality symbolised by water.

*In the villager's reflection one can see the land of his birth. Her skin is cleansed by waters, her body fed from the earth. Harmony prevails. Communities are their own guardians and custodians of their children's future.*

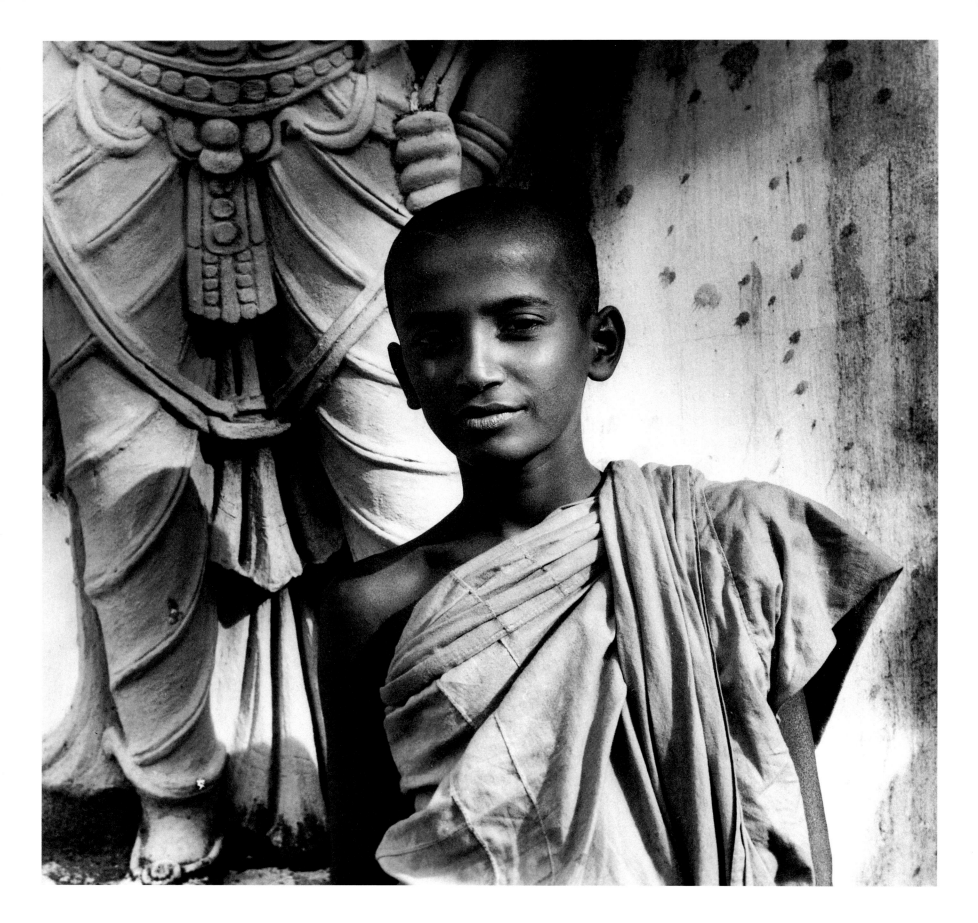

108 A novice monk, Tissamaharama.

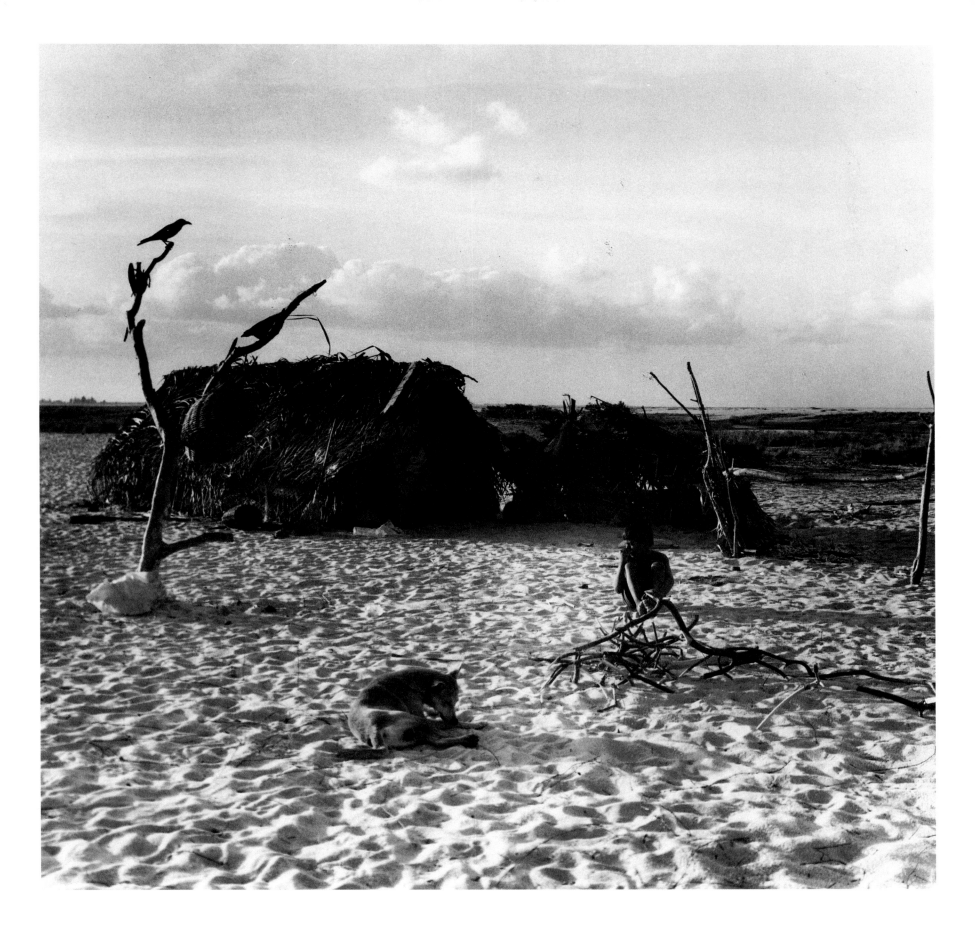

A boy guards his fishing wadiya, Batticaloa.  109

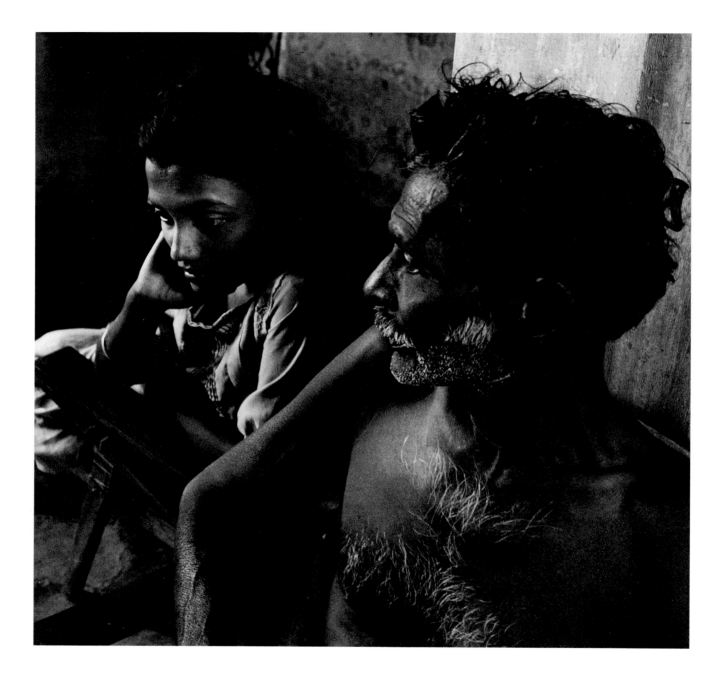

110 Father and daughter, Weligama.

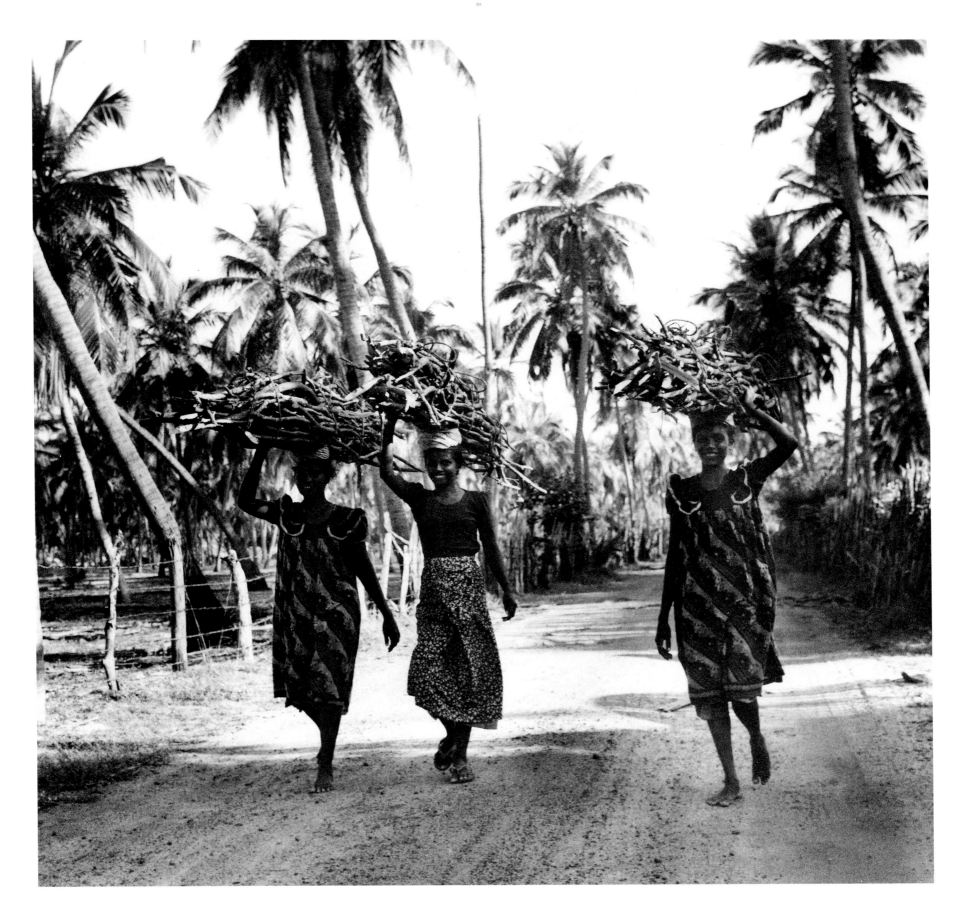

Women carrying firewood, Udappuwa. 111

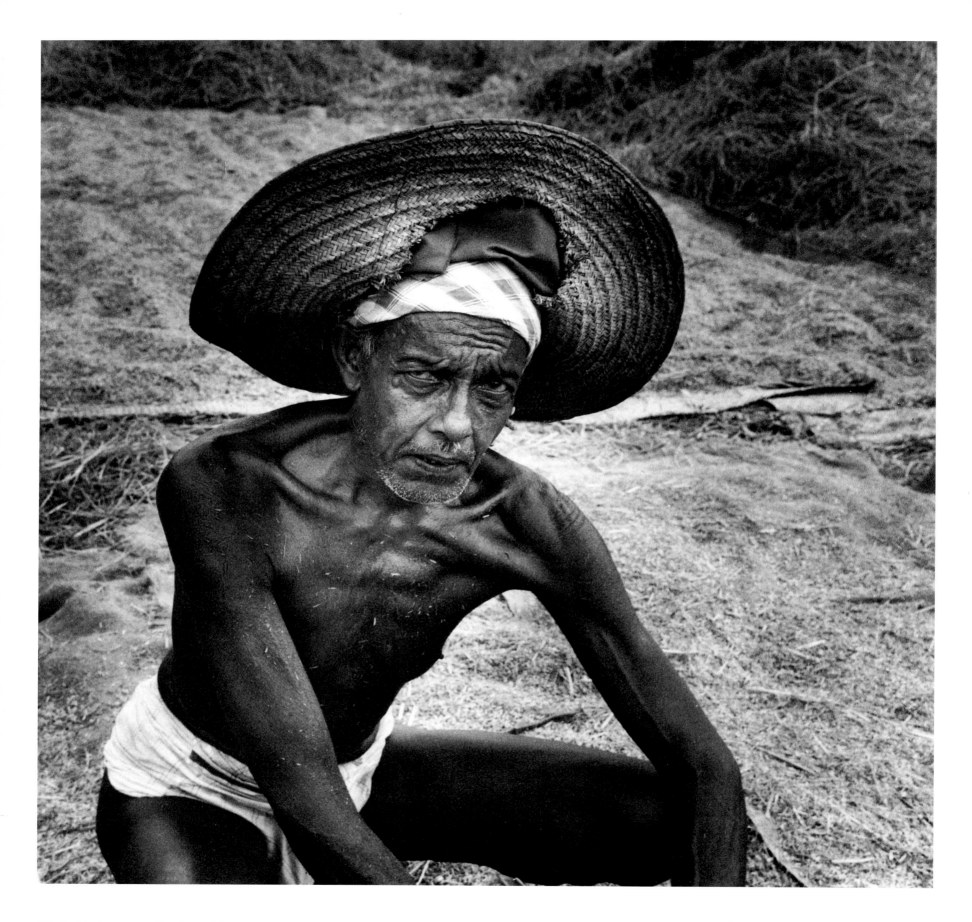

112 Paddy harvester, Kamburupitiya.

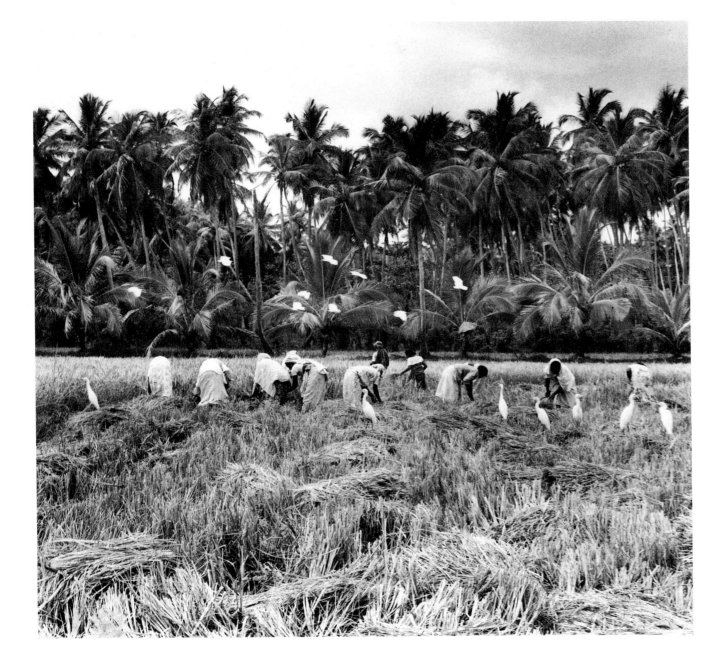

Paddy harvest, Kamburupitiya. 113

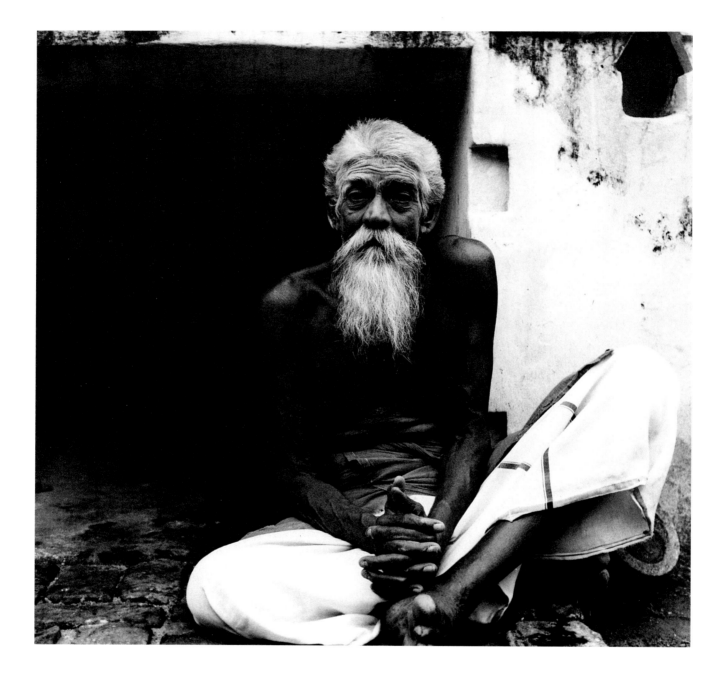

114  Swami, Kataragama.

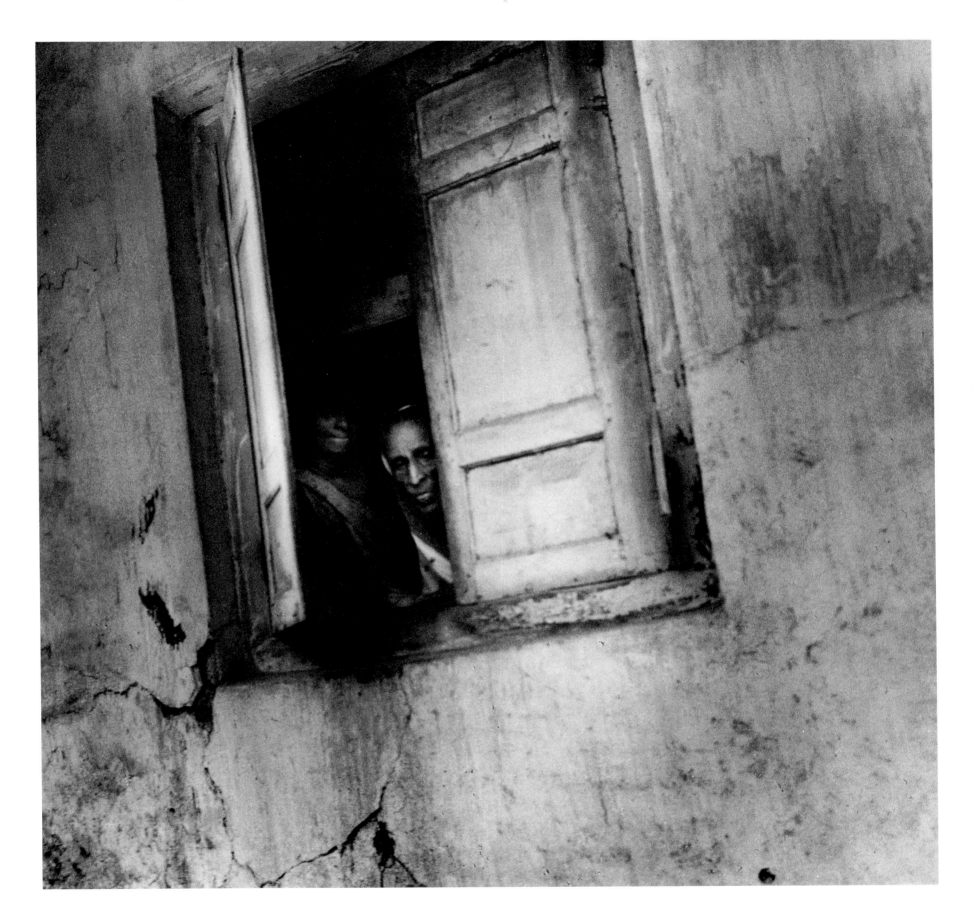

Two women in a window, Weligama.  115

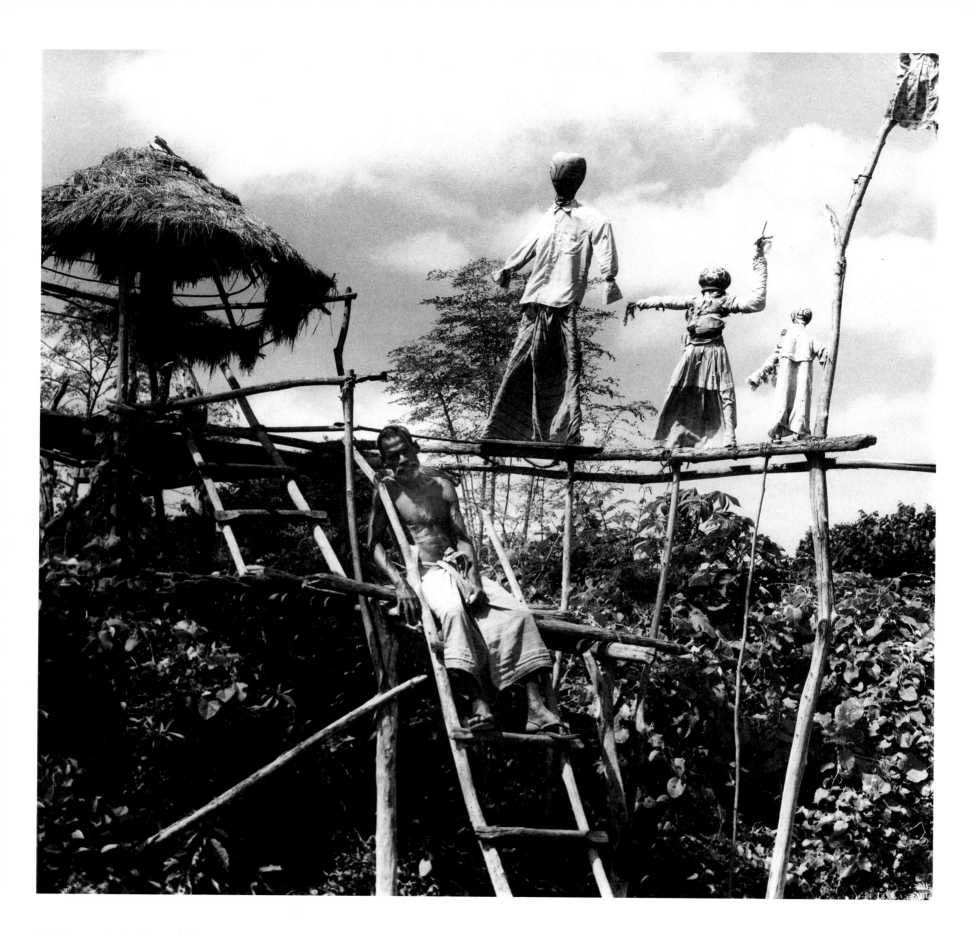

116 A man sits in his roadside sculpture, his look-out and figures to spot intruders and to ward off evil spirits, Habarana.

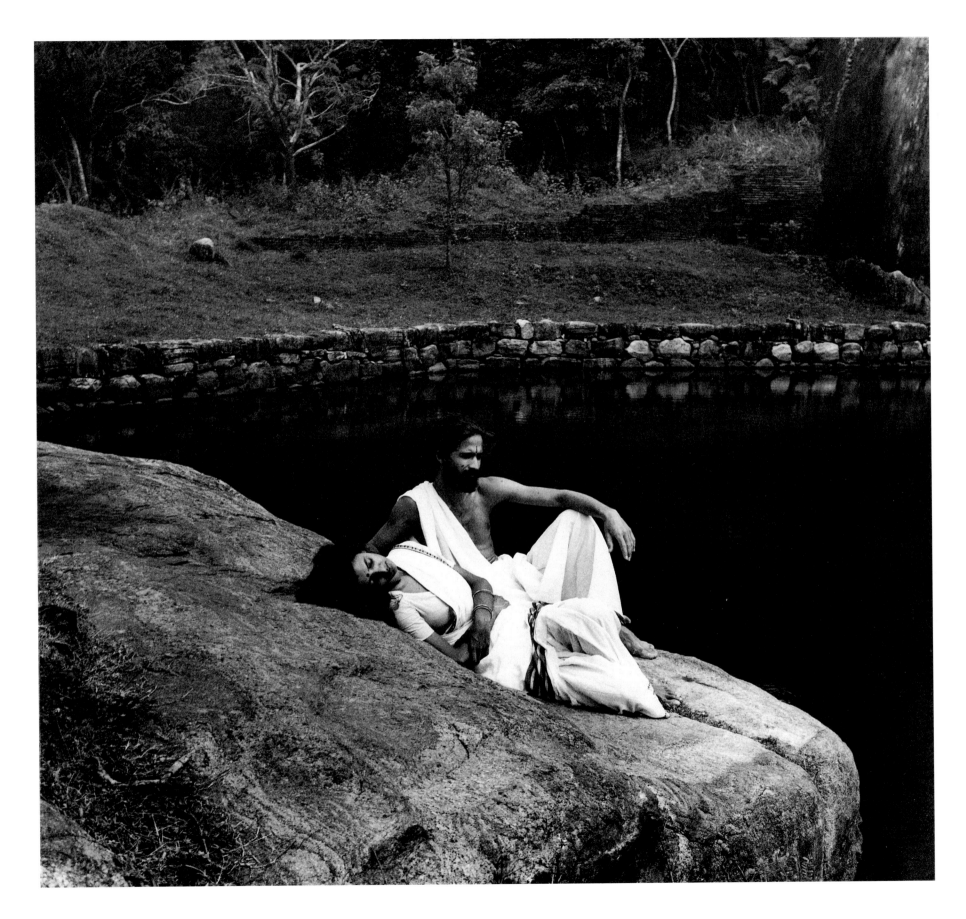

Lovers, Sigiriya.  117

WHO KNOWS THE TASTE OF MILK KNOWS MOTHER

WHO KNOWS THE TASTE OF RICE KNOWS FATHER

WHO KNOWS THE TASTE OF FRUITS KNOWS EARTH

ANYBODY WHO DOESN'T KNOW THESE THINGS

FOR WHAT WERE THEY BORN?

*Sinhalese Poem*

Shaman, Sigiriya. 119

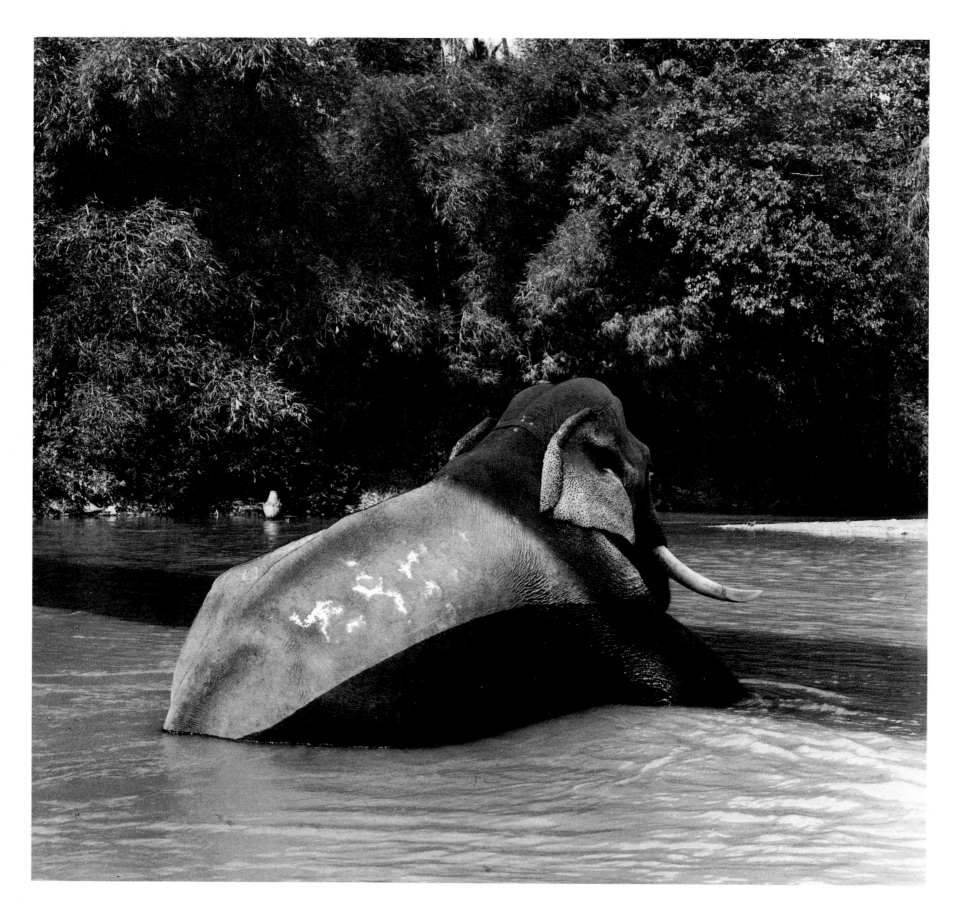

120 Elephant, Ratnapura.

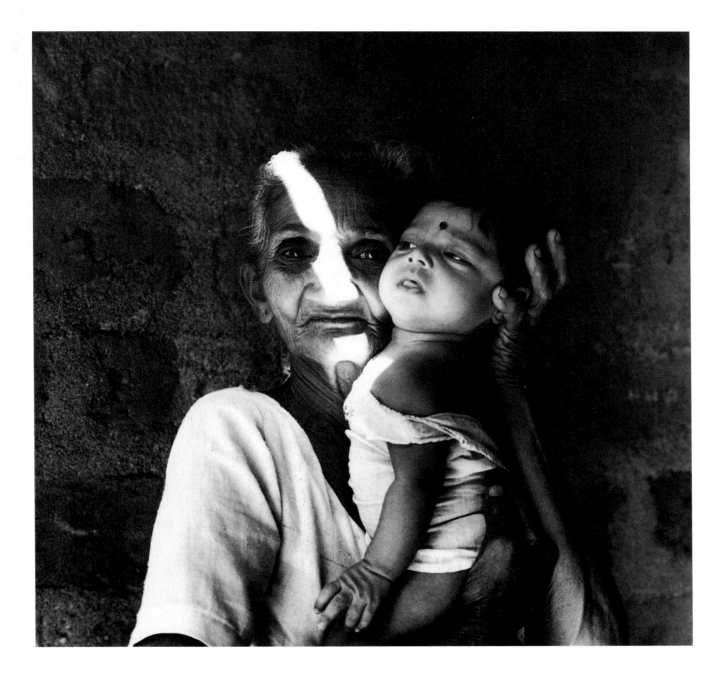

Grandmother and child, Galle. 121

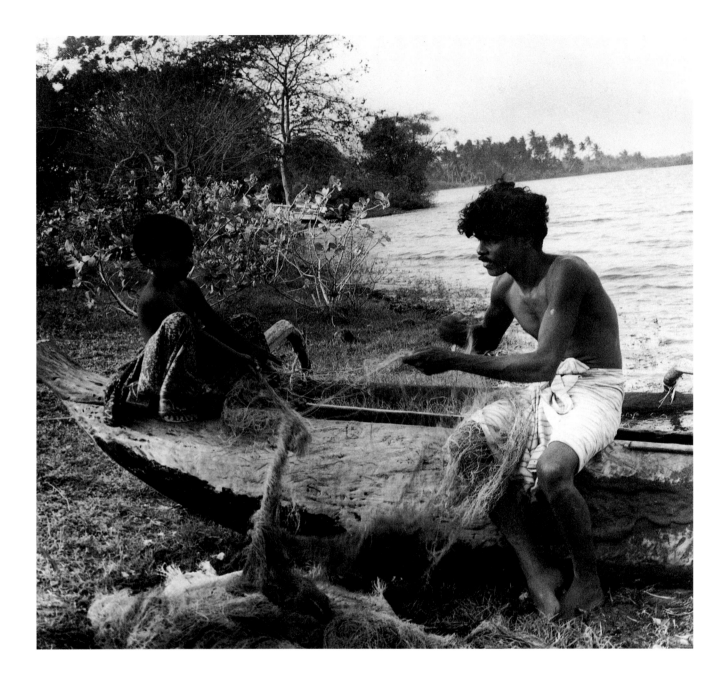

122 A son learns his father's art of net mending, Vakarai.

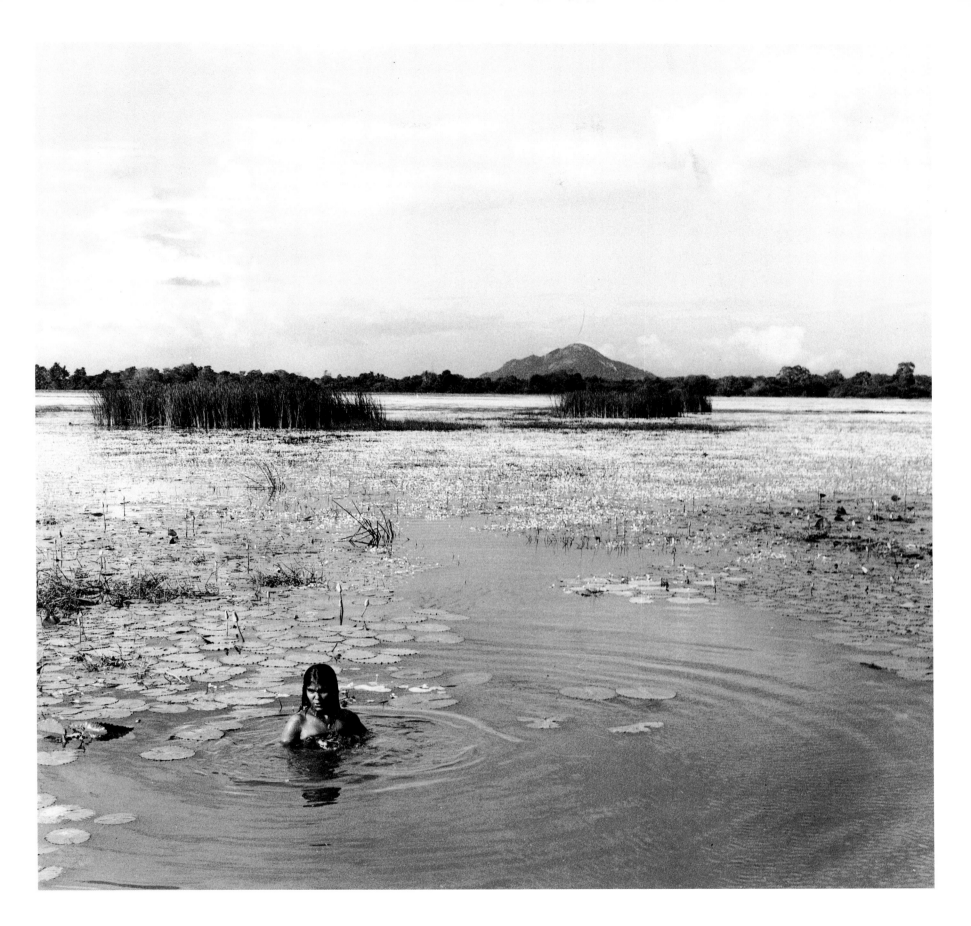

Woman bathing in a tank near Anuradhapura. 123

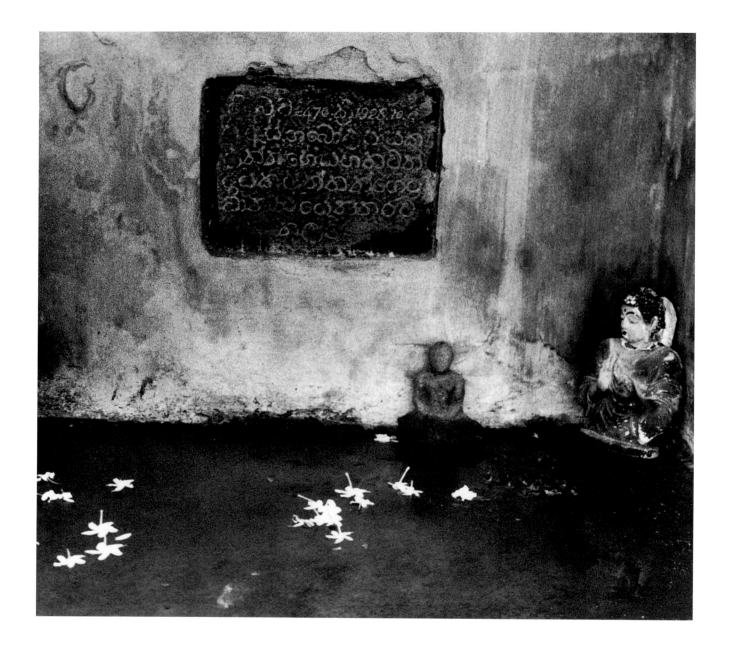

124  Buddhist shrine, Devinuwara.

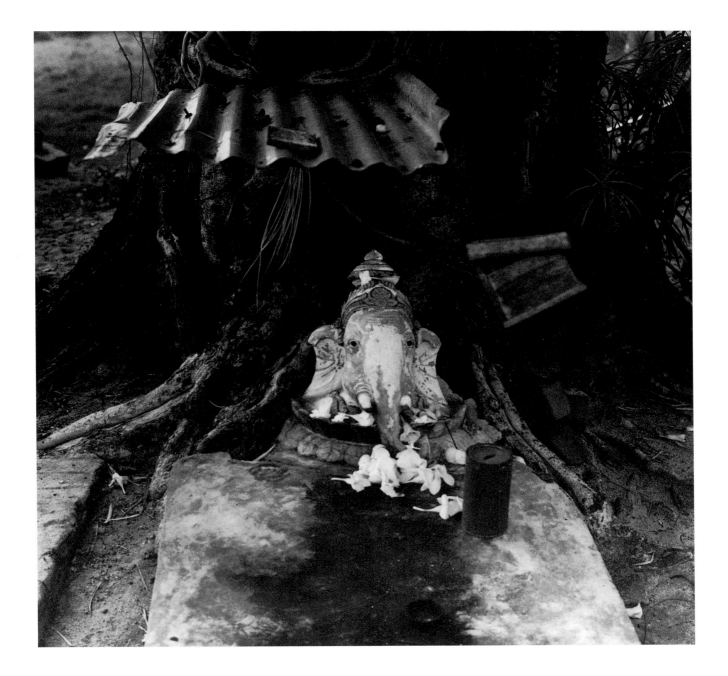

Hindu shrine. 125

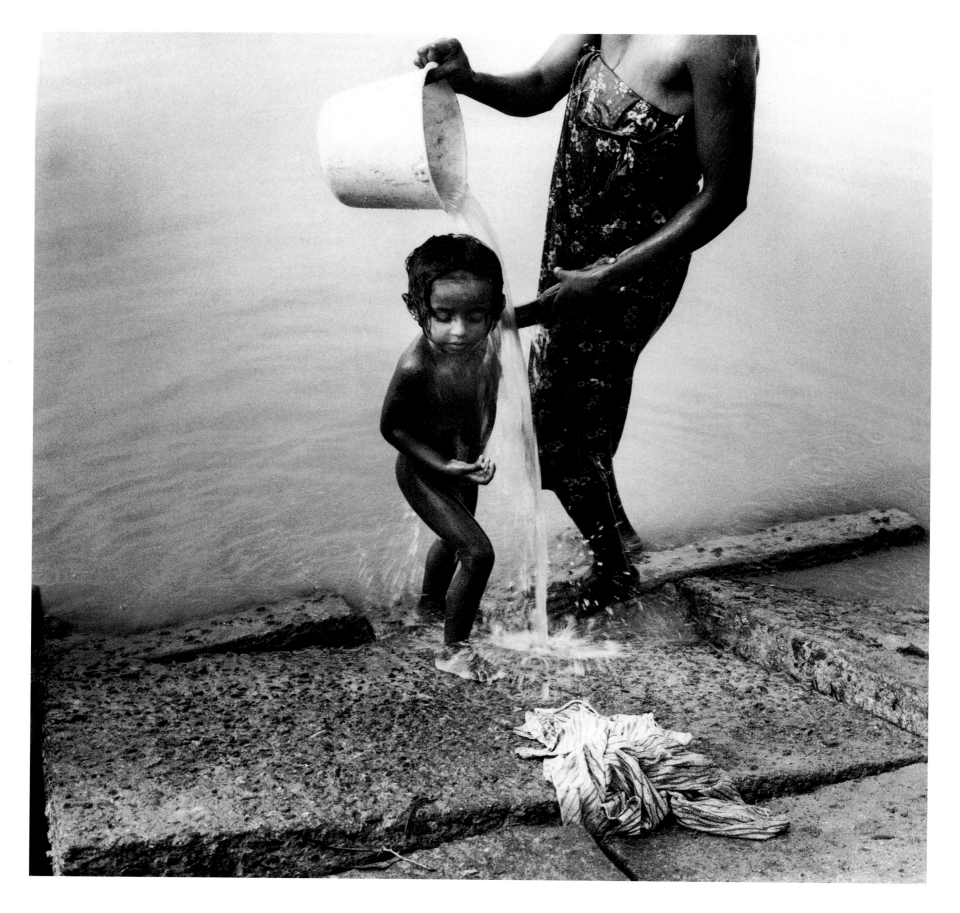

126 Mother bathing child near Tangalla.

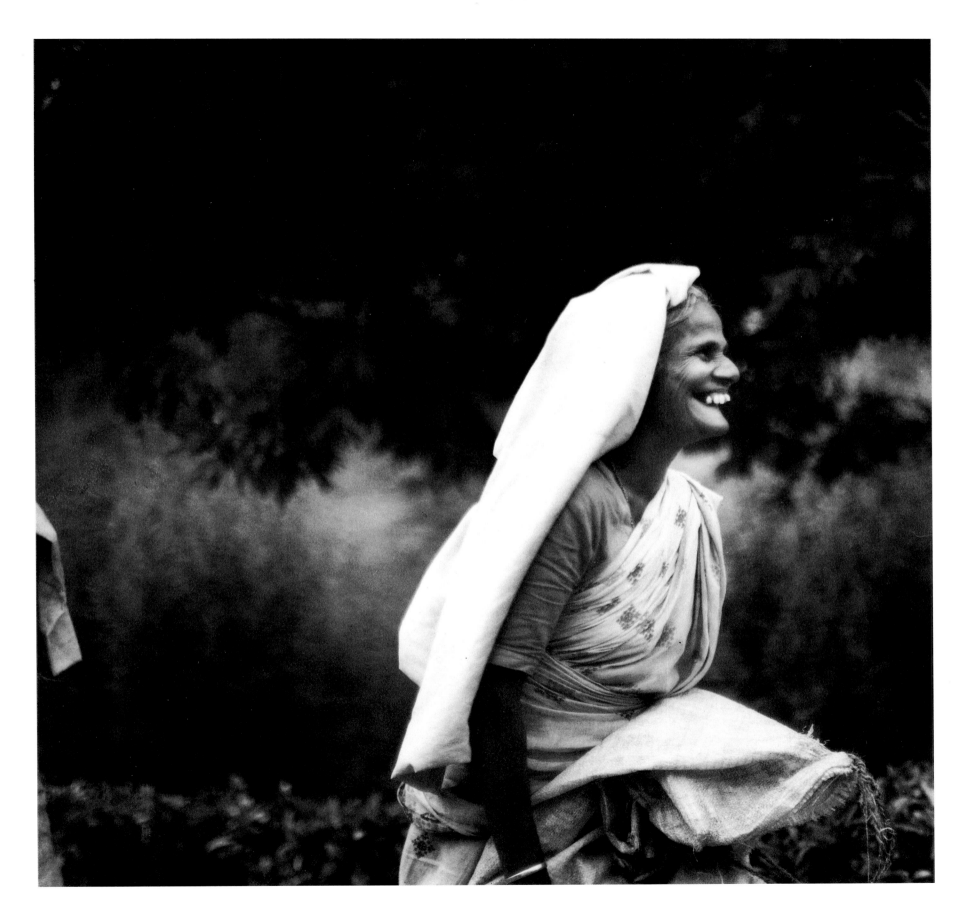

Tea estate worker. 127

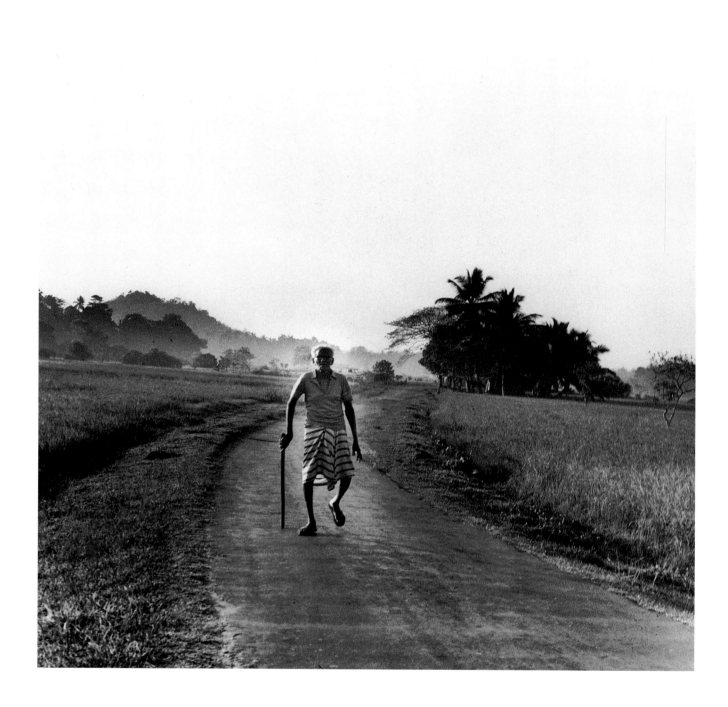

128 Early morning walk near Elpitiya.